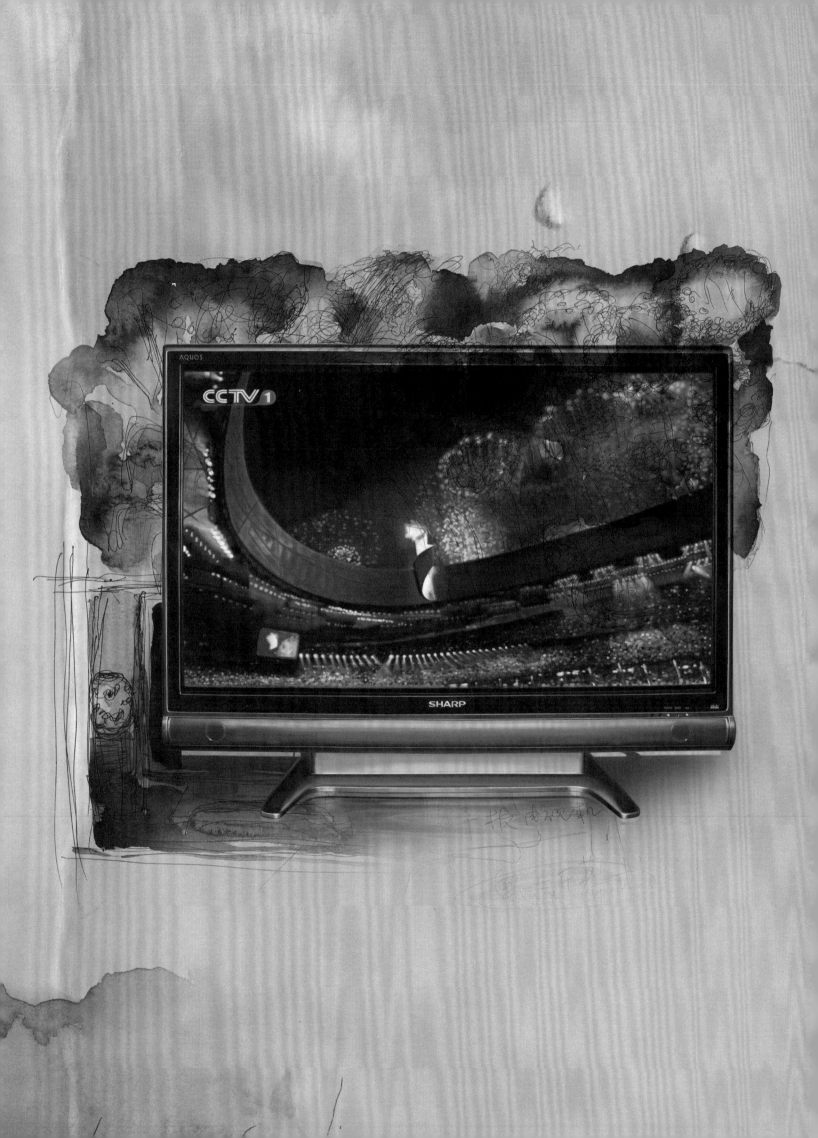

# 陳 Chen Xi
# 曦 So We Remember

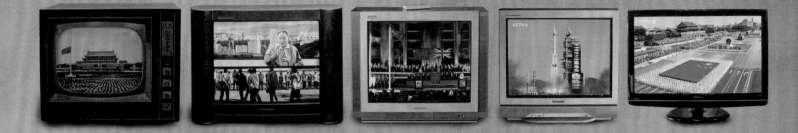

所以記憶

 香港大學美術博物館
University Museum and Art Gallery
The University of Hong Kong

# 陳曦：所以記憶
# CHEN XI: SO WE REMEMBER

學術總監 ACADEMIC DIRECTOR
羅諾德博士 DR FLORIAN KNOTHE

策展人 CURATOR
吳秀華博士 DR SARAH NG

作者 AUTHORS
羅諾德博士 DR FLORIAN KNOTHE, 吳秀華博士 DR SARAH NG, 陳曦 CHEN XI

出版 CO-PUBLISHERS

香港大學美術博物館
University Museum and Art Gallery
The University of Hong Kong

馬德松 CHRISTOPHER MATTISON
香港大學美術博物館 UNIVERSITY MUSEUM AND ART GALLERY,
THE UNIVERSITY OF HONG KONG

吳雨秋 NEO NG
《藝術香港》雜誌 ART HONG KONG MAGAZINE

《藝術香港》雜誌展覽執行 EXHIBITION EXECUTIVES AT ART HONG KONG MAGAZINE
陳亞梅 ANGIE CHEN, 周瀟嶷 SHALLY CHOW, 彭馨雨 PENNY PANG

英文翻譯 ENGLISH TRANSLATION
周瀟嶷 SHALLY CHOW

中文翻譯 CHINESE TRANSLATION
周政 EDWARD ZHOU

攝影 PHOTOGRAPHY
魏雲峰 BEN WEI

設計 DESIGN
何寶妮 PAULINE HO, 許馥楠 FUNAN XU

版次 EDITION
二零一六年三月 MARCH, 2016
© University Museum and Art Gallery, The University of Hong Kong, 2016
© Illustrations by Chen Xi

國際標準書號 ISBN
978-988-19023-5-1

香港大學美術博物館　香港般咸道九十號
UNIVERSITY MUSEUM AND ART GALLERY, THE UNIVERSITY OF HONG KONG
90 Bonham Road, Hong Kong

# 目錄
# Contents

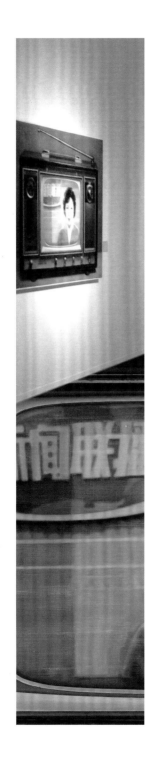

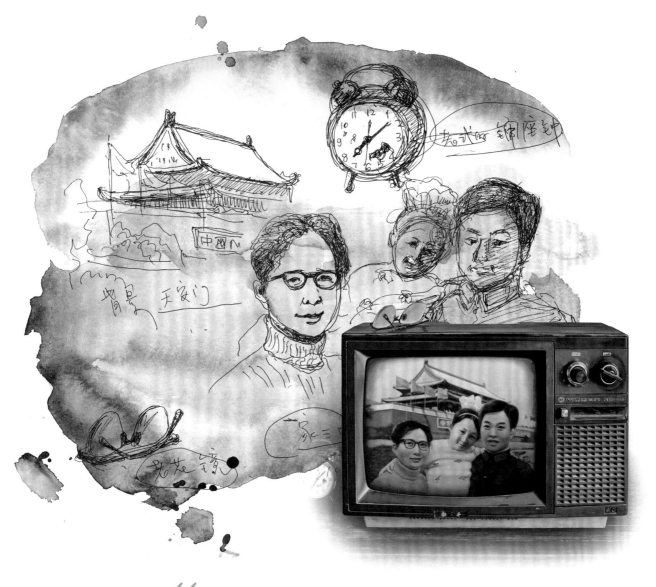

# 前言
# Foreword

羅諾德博士
香港大學美術博物館總監
**Dr Florian Knothe**
Director
University Museum and Art Gallery
The University of Hong Kong

香港大學美術博物館很高興與藝術家陳曦
合作，舉辦是次《陳曦：所以記憶》展覽，
展出她的《被記憶》繪畫系列，用以紀念、
記錄並啟迪思潮。繪畫題材取自世界大事。
是次展品包括油畫和鉛筆及水彩畫底稿。陳
曦秉持嚴謹的研究態度，並捕捉和記錄事件
的細節，為現當代和將來創作了富有歷史意
義的作品。她的創作手法與當代生活，以及
被現代媒體塑造和影響的社會息息相關。藝
術家並非只描繪個別歷史事件，而是將其井
然有序地置於其畫筆下的電視屏幕中。通過
電視屏幕，事件仿如屏幕截圖，連結至特定
的時空，也連結至在客廳收看電視的觀眾。

觀看陳曦的作品，都會勾起這些有廣泛影響
的政治或社會事件的記憶。同樣，觀眾從作
品描繪的世界大事中，甚至會產生不安及親
臨其境之感。藝術家與藝術的對話，喚起並
重現了對這些事件的觸動和敬意。我們感謝
陳曦的分享，這次展覽有如與其親密接觸。
另外，我們還要誠摯感謝《藝術香港》雜誌
社大力支持此次滿是回憶的展覽！

The University Museum and Art Gallery is delighted to collaborate with Chen Xi on an exhibition of work from her series *Be Memorized*. The paintings illustrate important events that have shaped our modern world. The artist created this series of contemporary images to commemorate, to document and to provoke thought. In the current show, we present her preliminary pen and watercolour drawings along with the finished oil paintings. Meticulous in her research and true to both the documented incident and the domestic details, Chen Xi creates historical paintings for our present and future generations. Her method directly relates to contemporary life and to a society that is informed and influenced by modern-day media. Interestingly, the painter does not simply depict a historic event, but frames within a TV screen each episode of her sequential and international narrative. By presenting the paintings within the TV's glass, they become screen shots linked to a specific moment in time and space, as well as to the living room setting where the news would have been seen.

Chen Xi's connection to her audience is as multifaceted as the international community viewing the paintings. Individuals are reminded of the broader implications and specific details of the political and social events being depicted. In concert with this, viewers are drawn in, sometimes uncomfortably close, to the domestic interior within the work. The artist's dialogue recalls and re-presents a moving tribute to the events, and we are thankful to Chen Xi for this opportunity to share such an intimate encounter. We also would like to express our gratitude to ART HONG KONG MAGAZINE for their support of this evocative exhibition.

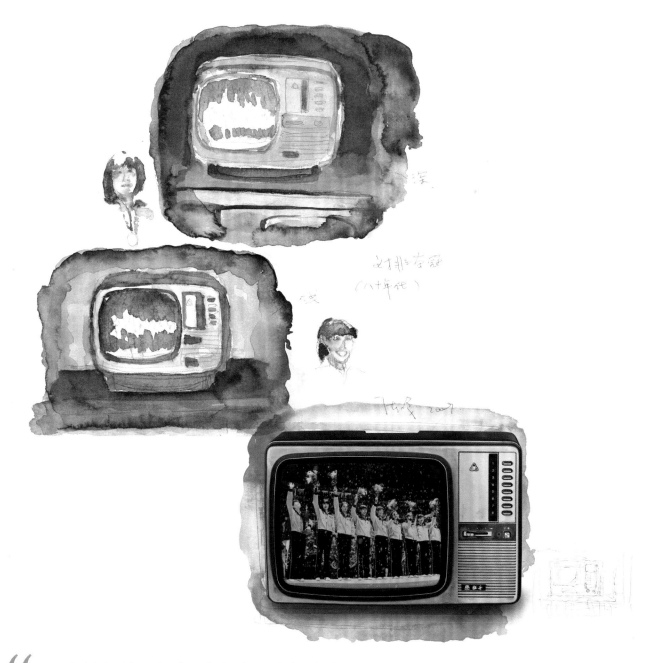

66 四十餘年的電視觀看改造了人們太多，
在快速便利的接受信息了解世界的同時，人們的時間也
被偷走，人們頭腦中被迫混雜了太多的垃圾信息，
真假難辨的報道以及洗腦般讓人渾噩呆癡的娛樂節目。
Forty years of television has transformed people
into beings that require quick and
convenient access to information. 99

# 自述
# Artist's Statement

陳曦
藝術家
**Chen Xi**
Artist

當決定再寫點什麼來作為此次展覽的自述時，我本期待這是對之前創作的一次深層審視後更加清晰的表述，因為幾年前在中國美術館展出《被記憶》時所寫的兩篇文字已與今天的感受有了距離，而這種距離引出的遺憾也仿佛隨著時間的推移在增長。然而提筆時才發現那幾乎是跟幾年前梳理時一樣艱難的事。我認識到無論何時面對畫面中那些歷史圖像，它們依然還是一部關於一個大國四十餘年發展史的巨著，裡面涵蓋的內容層次極其複雜，裹挾的幾代人的情感也是一言難盡的。

二零零六年當我決定花幾年時間去完成這個系列時，就十分肯定的預感到將會引起的反響，更大的可能會在一些非審美角度的層面引起廣泛的共鳴及討論。而延續至今的不斷展出，證明人們的反映比我想象的還要持久。

於是我再次回望這些作品時間自己，人們到底對它的什麼感興趣？

恐怕首要的還是那些屏幕裡呈現的歷史畫面吧。因為那是一些讓億萬人此生都不可能忘記的大事件，這些大事件在推動這個國家的

When I sat down to write an artist's statement for the current exhibition, I expected it would be easier to articulate my thoughts about the work, based simply on the amount of time I've had to reflect on the paintings since the two essays I wrote to accompany the *Be Memorized* series for a show at the National Art Museum of China. However, when I actually started to write, I found it nearly as difficult to put the series into words. I quickly came to understand the complexities associated with the historical scenes in the paintings, as they span forty years of the development of a massive country that is constructed on several generations of intangible emotions and commonly held narratives.

Back in 2006 when I first began the series, I understood the potential repercussions, and the possibility that much of the discussion would be centred on non-aesthetic issues. The show's continued appeal confirms that people's responses have been more nuanced than I could have imagined.

Whenever I consider the paintings in relation to a new audience, I ask myself, which aspect of the work will be the most compelling?

I believe the audience generally focuses on the memories linked to the historical images painted on the TV screens. These were seminal events viewed by hundreds of millions of people who are not likely to forget the events during their lifetimes. There are also the memories of the suffering inflicted on the spirit and flesh of individuals who lived through those times with a combination of pain, betrayal, fear of the dark, and despair in the wake of the country's development. When people review these historical images, they are seized by bittersweet memories and emotions; people are thrust back into perennial nightmares; pains suffered so long ago strike again.

進程路途中，也同時把對信仰的背叛，黑暗的恐懼，摧殘的傷痛，絕望的期待，此等種種痛感，無情的碾過那些過來人的靈與肉，我猜想當看到這些歷史圖像的時候，苦樂交織的深刻記憶就如常年夢魘一般再次抓住人們的圖像記憶和內心情感久久不放，那些也已久遠的痛感又會再次襲來……

其次人們感興趣的，應該是電視這個媒體在這段四十年的時間裡對每個家庭以及個人造成的深遠影響。人們對電視如敬神一般的依賴信任，也必然導致這部分人的半生記憶與之相關。四十餘年的電視觀看改造了人們太多，在快速便利的接受信息了解世界的同時，人們的時間也被偷走，人們頭腦中被迫混雜了太多的垃圾信息，真假難辨的報道以及洗腦般讓人渾噩呆癡的娛樂節目。在電視傳播幾乎快要被新興網絡媒體傳播替代的今天，問題伴隨著更加快速的發展也不斷湧來，許多問題已纏繞在一起難以理清，人們只顧在今天的狂歡中盡情享樂，而把糾結困惑都懸置起來……

語言的恰當與完善當然成就了這個系列的觀念性表達，也打破了「繪畫」這樣的舊容貌可能遭人嫌棄的局面，直逼觀者視線的結構，使得人們產生於爛熟於心的審美習慣下的漠然也被狠狠的觸動了一下。然而語言在這個系列中的價值恐怕還是次要的，史詩般的宏大敘事主題，終究是多數場域中的絕對主角，《被記憶》也是如此。

What should most interest people about the series is the significant influence exerted on them by the media through their television sets. People trust their TVs in the same way that they worship God, which has inevitably contributed to a lifetime of shared memories. Forty years of television has transformed people into beings that require quick and convenient access to information. At the same time, they are brainwashed by the floods of worthless entertainment and programming that blurs the line between what is true and what is false. Nowadays television has nearly been replaced by the Internet and various new forms of media, which inevitably leads to further entanglements associated with the rapid development of these new forms. People wrap themselves up in the pleasure that they receive from the entertainment and ignore the complexities of today's world.

A fully formed language has been achieved within the conceptual framework of the series, and individuals have been deeply touched by the events through the traditional medium of painting. However, the value of this language in the series remains a minor aspect; the grand narrative takes absolute priority.

With this in mind, I am particularly interested in watching how people from different backgrounds experience the series. How do people from here, or visitors from various parts of the world, respond to the work?

Someone once commented it was surprising that the *Be Memorized* series had been created by a female artist; throughout my career, these particular paintings have remained dear to me, as they have helped to identify specific angles and depths to explore within the broader themes. Since the time of my graduation, this series has been constructed on a prolonged and profound series of observations.

想到這些，我對此次展覽有了新的好奇感。我想這是一次觀察在不同背景下，人們反映的機會，這裡的人們，還有世界其他地方來的人們，會怎樣去觀看？怎麼去想⋯⋯

有人說《被記憶》太不像我（女性）的思考和表達，在我的創作生涯中，這個系列是足夠特殊的，但那僅僅是因為通過它我實現了自己想要丈量的緯度和深度。從內核的層面而言，它其實就是我自畢業開始對所處周遭環境的那樣深情且長久觀察描繪的繼續，一種內在線索的追蹤。

當然此時的我早已轉身別處了，依然還是找回繪畫的溫度手感，讓一切表達都更加自由的流淌出來⋯⋯這也更接近屬於我內心世界的理想狀態。

而《被記憶》，必然是屬於眾人的⋯⋯

2016.01.29

I have since moved on to other modes of painting, in which I create work by allowing personal expression to flow more freely, which is something closer to my ideal state of an inner world.

*Be Memorized* must belong to everyone.

2016.01.29

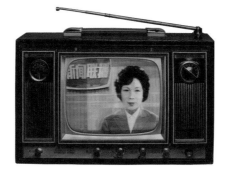

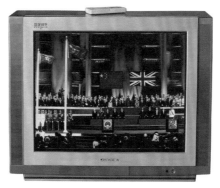

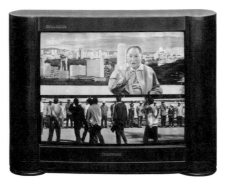

“ Chen Xi's alternative form of history painting
articulates the artist's viewpoint—
one that conventional history painters from
bygone eras were prohibited to express

陳曦採用的藝術形式則改變了這種傳統
歷史畫的常規。作品努力闡述藝術家的觀點，
即那些以往在歷史畫中被禁止表達的觀點。”

# 作為溝通方式的當代歷史畫
# Contemporary History Painting as a Means of Communication

羅諾德博士
Dr Florian Knothe

在藝術上，歷史題材繪畫的探討是層次多樣且經久不衰的。可惜只有很少當代藝術家能夠在這領域中有傑出的作品，或將其運用為一種溝通媒介，包括採用真實或虛構的方式呈現。在此背景下，陳曦的那些內涵豐富且引人深思的作品，是對這種具有歷史意義的藝術形式的現代補充。

陳曦作為中國地區電視台節目總監的女兒，縱然已成為藝術家，但因父母職業的影響，她鍾情於電視新聞報導，以及傳播媒介中對政治事件的報導觀點。她的《被記憶》系列繪畫除以超自然的繪畫風格再現了許多部電視機外，也記錄了一系列令人印象深刻並對社會產生深遠影響的國際事件。當你第一眼欣賞陳曦作品的時候，觀眾很容易感受到她的率直表達方式，而她傳遞的信息也體現在她畫筆下的大制作繪畫並呈現其一致的風格。當再次觀看陳曦的作品時，觀眾便能充分體會到她有感於社會被電視媒體操縱下的批評。

在傳統上，歷史畫的構圖和不同層次的解釋均經過精心包裝去歌頌作品的贊助者，以達到政治目的和影響社會。陳曦採用的藝術形式則改變了這種傳統歷史畫的常規。作品努

The discourse on historical representation and the genre of history painting is multifaceted and enduring. However, few contemporary artists have contributed significant new work to the field, or engaged with this medium as a means of communication—either in a truly documentary or fabricated manner. In this context, Chen Xi's work, which is multi-layered and thought provoking, presents an interesting modern take on this historic art form.

The daughter of a programme director for a regional TV station in China, Chen Xi is a well-established Beijing artist who has long been fascinated with television news reporting and the representation and communication of political events in the media. Her series of paintings *Be Memorized* depicts TVs in a hyper-naturalistic style of painting, and records events of national and international importance that impressed and influenced society. At first sight, her forthright presentation is easily understood, and her message appears to be supported by the broad and uniform character of her depictions. A second glance, however, reveals her underlying criticism of society and the simple ways that it is manipulated by television broadcasting.

Traditionally, the composition and layers of meaning within history paintings are carefully fabricated to glorify a patron and to exert political and social influence. Chen Xi's alternative form of history painting articulates the artist's viewpoint—one that conventional history painters from bygone eras were prohibited to express—reversing the effect of her illustrations. These documentary depictions intrigue by illustrating the artist's rather than an official authority's message. The painter selects individual topics, such as China's New Leaders or the Diaoyu Islands, which were reported in the news for a considerable length of time, and often with the same sanitised message and repeated video footage.

力闡述藝術家的觀點，即那些以往在歷史畫中被禁止表達的觀點。這些具有記錄性質的繪畫是藝術家對信息的圖解，而非單純來自官方機關的信息，這令人產生欣賞和了解作品的興趣。畫家挑選了許多特別的內容，都曾長期出現在新聞報導中，而且都被美化過，並重複播放，例如《換屆》或《釣魚島》。陳曦對這些重複報導的感知是雙重的，不僅癡迷，而且震驚。對她而言，這種千篇一律和經挑選的報導內容，是權力當局對資訊傳播的管制，對世界有著深遠影響。

陳曦作品是將歷史事件再現於大電視機裝置中。電視機幾乎佔據整幅畫面，這佈局意味深長。這些大型畫作令人想到電視機和電視新聞在人們生活中所扮演的角色。陳曦運用了一種傳統歷史畫中常見的構圖和策略，使創作的電視截屏比實際生活中所見的大，這強調了媒體的重要性，以及表達出畫中影像更深的潛藏含意及其影響。當事件與作品的主要信息交互之時，這種精心安排的「框架」，即環繞中心圖像的電視機裝置，便與當時發生的時空連結起來。每部電視機皆能配合其畫面展示事件的時代，以及接收新聞的家庭中。

這些作品構圖平凡、簡單，清晰表明了媒體影響下家庭的普遍特點，以及將所有新聞報導皆當作事實接受的情況。這使得陳曦的畫作與信息能被廣泛理解。媒體中的新聞進入我們的家庭中，並且成為個人生活的一部

Chen Xi is both fascinated and appalled by the repetitiveness of such reporting. To her this monotony indicates selective broadcasting and the influence—the world over—of authorities dictating the output of information.

The scale of the artwork is significant, as her large canvases are occupied almost entirely by oversize representations of TV sets displaying historic events. These large-scale depictions are reminiscent of the role that television and televised news play in our lives. The larger-than-life aspect—a commonly employed strategy in traditional history paintings—of the TV screenshots emphasises the importance granted to the medium and, on a more subliminal level, the influence that the broadcasted images hold. While the event communicates the primary message of each painting, the meticulously selected and depicted 'frame', the TV set around the centre image, connects the message to a particular time and space. Each TV precisely relates to the era of the event that it displays and the type of domestic interior in which the broadcast was received.

The mundane simplicity of the setup clearly highlights the near universal character of the home being influenced by the media, and the everyday situation—the acceptance of all news as truth—that makes Chen Xi's images and message broadly understood. Mediated news reaches into our homes and becomes part of our personal lives. The artist carefully studied the development of TV sets and the brands and models available in order to create a domestic frame that situates her imagery within our community and era. Her attention to detail makes this precise reference to the past almost indistinguishable, and the subject matter perfectly convincible and common.

分。藝術家陳曦仔細研究了電視機的發展，以及現有的品牌、型號，只為在我們的社會與時代中創造出一個放置她圖畫的家庭部件。她注重細節的描繪，尤其一些幾乎不易被人察覺的部分，同時也能傳遞出一種令人全然信服且普世的信息。

陳曦選用的主題幾乎完全關於中國，而且皆是對人類有巨大且持續影響的事件，除九月十一日紐約世貿中心雙塔的恐怖襲擊是唯一有關「外國」的例子外，全部都發生在中國。畫家不僅再次重現這些重要的國際事件，而且努力將之告訴普通平民百姓和將其置於「世界新聞」中的日常生活描繪。陳曦選了中國政府提倡多年的一孩政策、被長期報導的鄧小平開創的設立經濟特區計劃，和香港回歸等。除社會與政治事件外，還加入許多塑造了國家與國民的重要體育事件，比如歡慶北京奧林匹克運動會。此外，中國人為改造的環境也是另一個關注焦點。這些具有歷史意義的事件之所以被選畫，不僅是由於其固有的價值，而且也是因為其經過電視傳播的重要事實。陳曦關注的並非是被報導的事件本身，而是報導在人們中產生的影響。

通過這二十二個例子，陳曦使我們回憶起不斷被重複播放的重要新聞，以及提醒我們是如何輕信來自電視台的報導和分析。在此，藝術家努力喚起我們的思考，使我們變成媒體新聞簡訊的挑剔觀眾；她要求我們充分調動自我發現與自我感知的觸覺，變得更具反

Chen Xi's themes relate almost exclusively to China—the damaged towers of the World Trade Center in New York City during the 9/11 terrorist attacks being the only 'foreign' example—and they represent events that had an immense and lasting impact on humanity. The painter uses these internationally known incidents and extends her imagery into a portrayal of the common people and their access to and life within a world of 'world news'. Propagated for many years, the Chinese government's One-Child Policy is included in Chen Xi's selection, along with the long reported creation of Special Economic Zones under Deng Xiaoping, as well as Hong Kong's handover. Social and political affairs are joined by large-scale sporting events, such as the celebration of the Olympic Games in Beijing, which shaped the country and its citizens, along with examples of China's human-altered environment, including the Three Gorges Project. These historic endeavours are not included solely for their inherent importance, but also for the fact that they were made important by TV broadcasts. Here the motivation of the artist shines through, as her main concern is not the incident reported but the influence that the reporting had on people.

Illustrated in 22 examples, Chen Xi reminds us of the importance of the repetitive news cycle and our gullible acceptance of the analysis and presentation by television stations. Here, the artist strives to encourage us to think and to become more critical of the news bites that we receive from the media. She appeals to our sense of self-discovery and to our self-consciousness, and alerts us to be more reflective and questioning. Her proposition is both well received in today's society and uncomfortable, as few of us have access to the original sources and many suffer from limited exposure to a restricted and sometimes highly controlled number of news agencies.

思與質疑精神。這種主張既容易被今天的社會接受，同時也使人感到不安，因為我們中很少有人能獲得原始資料，且有很多人仍飽受新聞機構操控之苦。

這組非凡系列繪畫支撐著每幅畫作包涵的信息，不僅能喚起我們對事件本身的回憶，更在於提醒我們去關注接收這些新聞時的態度。這系列中也包含些許批評的意味，因為我們不得不相信所有新聞報導皆應客觀，不得不相信這些「值得紀念的」的事件，或至少是視覺再現和報導，也是經過篩選的。由此而言，藝術家陳曦所做的是要改變歷史畫的形式，以及對近代歷史事件的個別展示。在我們仍能記憶的過去中，陳曦已經創造了一系列記錄圖像，以紀念那些記憶中重要的歷史往事，以及反映我們對電視媒體的使用與依賴。陳曦正竭盡全力延續此系列的生命，直到電視媒介在社會中失去地位時才會停歇，陳曦會始終以觀察者的身份，檢視大眾傳媒編採、演繹和操縱優先次序的方式。

有趣的是，在當今這個滿是視覺表現和電子媒體的世界中，陳曦依然選擇傳統圖像媒介——繪畫，去評論那些被挑選的歷史事件，並且表現出技術的進步與發展。藝術家在紙本上的水彩素描稿和油畫，皆是精細非凡的精彩藝術作品，亦能使人回憶起歷史悠久的歷史畫傳統。其素描更具中國特色，而油畫則更西式，二者共同展示了藝術家在這種雙重模式下的創作天分。接近成型的

This remarkable set of images frames the message contained in each and every painting, which reminds us not just of the event but of the circumstances or conditions under which we received the news. It is also a somewhat critical remark, as we are made to believe that all news reporting is objective and that such 'memorable' events—or at least the visual representation and reporting—have been preselected for us. In this sense the artist engages with an altered form of history painting and the display of historic incidents in our near past. Recent enough for us to remember, Chen Xi has created a set of documentary images that commemorates milestones in history as well as our usage and reliance on TV broadcasting. Determined to continue this series until television as a medium has lost its importance within society, the painter remains a keen observer of the way that the mass media fabricates relevance and manipulates priorities.

Interestingly, in our world of visual representation and digital media, Chen Xi has decided to comment on the selected historic events, and to represent technical advances and developments, through the prototypically traditional medium of painting. Remarkable for the detailed polychrome compositions, both the artist's preliminary sketches in watercolour on paper, and her completed paintings in oil on canvas, are reminiscent of the long-established practice of history painting. The sketches are more Chinese in character and the oil paintings more Western, but both versions show the artist's talents for working in these dual modes. Both the advanced stage of the 'preliminary' works, and the fact that only minor changes occur in the transition to the completed paintings, are testament to Chen Xi's careful planning and the research and compositional skill that characterises her artistic process. It is the

「未完成」作品與完成的作品之間只有很少變化，這體現了陳曦藝術創作過程的特點，即精細的研究準備和豐富的創作技巧。正是由於畫家高質量完成了對所選擇時期與境況的初步研究，對事件本身的精確追蹤，以及高超的繪畫技巧，才能完成這組複雜恢宏的藝術系列。

quality of the painter's initial research into the time period and circumstances of the chosen event, her accurate tracing of the incident itself, as well as her skilful painterly technique, which leads to the successful execution of this large and comprehensive series.

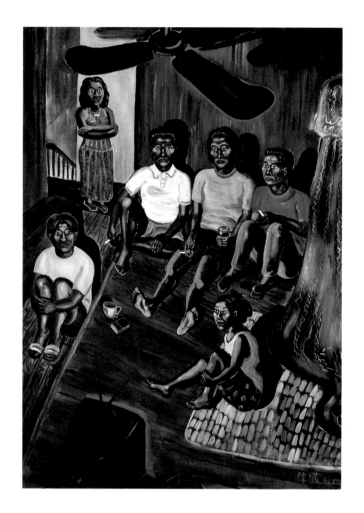

> 若言李希特的作品表現出相互矛盾的真實性，
> 陳曦的作品便是遊走於真實與虛構之間。
>
> If Richter reveals the conflict between
> the 'real' and the 'imaginary',
> then Chen Xi's works illustrate the state between 'reality'
> and the 'virtual world'.

# 從表現主義到超級寫實主義：陳曦的《被記憶》
# From Expressionism to Hyperrealism— Chen Xi's *Be Memorized* Series

吳秀華博士
香港大學美術博物館副館長

**Dr Sarah Ng**
Associate Curator
University Museum and Art Gallery
The University of Hong Kong

電視既可以把現實生活中一切的事物重現在螢光幕上，呈現客觀世界中摸不著、看不見、甚至虛擬的事物於觀眾眼前。通過細微的道具、場景、剪接與後期加工完成，達到逼真的效果，但這並不等同於真實。陳曦的電視畫面創作，也是真實世界與藝術真實的統合，也就是逼真性與假設性的統合，由她個人的觀感和經驗，在取材上有所選擇與重新安排。

她構建的世界有另一套的前提、假設、法則與習慣，包括特定的時空和場景。例如電視機旁邊不同的擺設，有早年的舊書、流行於五、六十年代的經典金屬熱水瓶、老花眼鏡和鬧鐘、不同年代流行的國產電視機品牌和型號、代表孩子純潔健康形象的娃哈哈瓶裝礦泉水、代表中國和中國產品市場的青花陶瓷罐，和當下中國社會流行的蘋果或仿蘋果手機等。雖然這都是後期製作的場景，跟真實世界有所不同，但藝術家認為她想像中的世界和現實世界都一樣的真實和重要。她筆下的現實是其主觀觀照下的客觀世界。

If TV has the ability to present the world around us on a screen—displaying intangible, invisible and even virtual objects—then stage props matched to the different scenes provide the clips with a more lifelike feel after editing and post-production of the content. However, this realistic effect remains remarkably unreal, and is never quite the same as reality. Chen Xi's painted TV screens, which capture episodes at a particular time and space in ordinary homes across China, are a combination of reality and her artistic simulation or illusory reality. It is as if she is combining reality with its hypothesis, which originates in her personal understanding and experiences; therefore, she has carefully chosen specific events and objects and then rearranged them in her paintings.

The world that she has created relies on a set of premises, assumptions, rules and conventions that likely differ from those in our objective world, such as the specific time, space and individual scenes being presented. For example, the various objects displayed next to the TVs include: old books, a 1950s and '60s era metal hot water bottle, reading glasses and alarm clock, various TV brands (both local and foreign) and models produced in different periods, *Wahaha* bottled mineral water (The Chinese brand *Wahaha* promises pure and healthy children), a blue and white porcelain jar representing the Chinese identity and markets in the West, iPhones or fake-iPhones and electronic devices next to an apple. Although these episodes are all post-production scenes, which differ from the real world, the artist portrays her imagined world as the reality; to her they are identical and of equal importance.

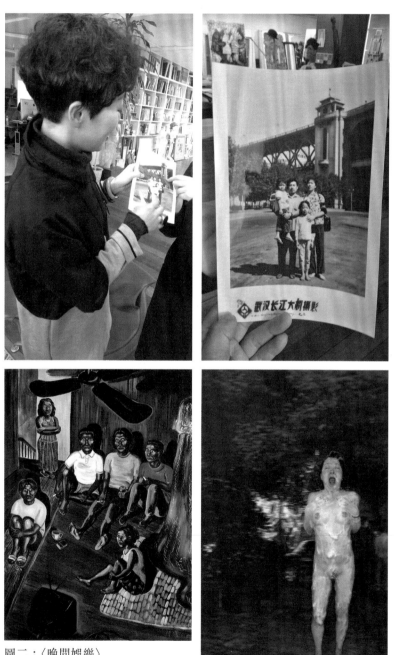

圖一：陳曦解釋其友人
一家的合照。（筆者攝
於陳曦位於北京的工作
室，15/2/2016）
Fig. 1: Chen Xi shows
the picture of her
friend's family at
her studio in Beijing,
15/2/2016, photo
courtesy of Sarah Ng.

圖二：〈晚間娛樂〉
Fig. 2: *Evening Entertainment*

圖三：〈夜12點〉
Fig. 3: *12 o'clock in the Evening*

當作品完成後，看似螢幕擷取的新聞片段如現成照片般被視為真實的客觀記錄。然而事實是一系列經過藝術家精心策劃、設計和鋪排的畫面，絕不是現實的原貌，由選擇以新聞報導方式表達，並以過去主要發生在中國及對中國有重大影響的事件作為電視畫面內容，到描繪的電視機型號和所擺放的位置和場景都全非偶然。

陳曦也不只有天馬行空的創作，她如歷史紀實片的導演般，創作前先做歷史事件的圖片資料搜集，然後透過訪問了解民眾對電視機在生活中的角色、對媒體報導的觀感等，再研究和購藏不同年代出品的電視機，運用從政府新聞資料庫、網絡資源等現成影像圖片，利用電腦技術加入場景和配合不同款式的電視機構圖，創作出電腦合成圖後，再以油畫表現出來。

電視機表面上是單向性的溝通，實際上是關於中國人的集體歷史記憶，個體如何接收、理解資訊。這會因接收者的背景，如學歷和人生經驗，而有不同程度的影響。如〈只生一個好〉是大陸一孩政策剛實施後，以陳曦友人的一家為畫中主角而創作（圖一），事實上他們從未曾在天安門前拍過合照或曾出現在央視新聞中。她透過刻意營造的螢幕擷取畫面，將客觀事實再以電視或新聞報導畫面呈現出來。在觀點鏡頭的運用上還可以將觀眾捲進影片之中，使觀眾有強烈的主體介入性，達到置身其中的心理效果。

After each painting is completed, the refabricated TV news shot is presented as objective evidence, as a photographic recording of the event. However, the artist's meticulous planning of the composition results in an image that no longer merely depicts the reality of the original scene. The paintings are all constructed from selected news bites that were reported from a specific perspective. Most of the major events took place in China, or else have had a significant impact on China, such as 9/11. There is nothing coincidental about the objects, from the models of TV to the individual angles chosen to display the events.

In the *Be Memorized* series, Chen Xi turns ideas into artworks and constructs her paintings based on intensive research. She acts as a documentary director who not only produces and determines the quality of the work, but also carries out the data collection and research before filming. She scours through books searching for pictures depicting the events, studies the history of TV's development in China, purchases vintage TV models from various eras and conducts interviews on how the media affects our daily lives. Photographs that she purchases from the government news database are combined with Internet images. After she finalizes each layered image, she begins to paint with reference to the fabricated digital print.

TV may appear to be a unilateral or one-way form of communication, but it is, in fact, constructed on the collective memory of a people. It includes their perceptions of the past and how people have received and understood historic events that were broadcast on TV. The level of impact varies by individual background, including one's education and experience. For example, the 'One-child Policy' painting in the *Be Memorized* series is concerned with the population control measure imposed by the Chinese government around 1980. In the painting, the family members

她一直強調「作品中的電視畫面沒有其個人情感視角」[1]，而她關注的是，媒體報導事件的立場，以及事實和社會民眾如何詮釋媒體報導的關係。究竟觀眾有沒有想過電視媒體如何選材和報道事件的立場和真實性。

陳知道不同時代的政治符號和流行的宣傳媒體都會有所改變，如同象徵文化大革命的大字報和旗幟、象徵權威的中央電視台、象徵傳送者的電視機等。

從2006年開始，陳曦便因一次經營MTV友人的邀請，開始創作這《被記憶》系列油畫，由2009年的十八張作品增加至目前的廿二張。將她從早年野獸派和表現主義等風格（圖二）轉移至近乎另一極端的超寫實主義風格，是一次個人藝術發展的里程。儘管繪畫風格迥異，如陳曦的自述一樣，一切都是過往經驗和技巧的累積而演化出來，有其清淅的脈絡。

如八十年代的作品多取材自她在四川美術學院附屬中學的回憶，九十年代則較多以寫實手法描繪身邊微不足道、普通市井百姓的日常生活場景，是現實生活的寫照。

standing in front of Tiananmen Square are friends of Chen Xi. They never actually took this photo of themselves at Tiananmen Square (Fig. 1). She has deliberately constructed this picture in order to imitate a similar image that was broadcast by China Central Television (CCTV, formerly known as Beijing Television) news. Because of the camera angle and the painting's composition, which resembles a photograph taken at home in front of a TV set, viewers feel as if they are watching the TV news at home and engaging directly with the TV.

Despite this, she emphasises that "the pictures shown on the TV screens in her paintings have no personal connection to her, and that she has never imposed any hidden meanings or her own perspective." [1] She is more concerned with how the media interprets events through television, and how people respond to the media reports. She wants to understand the precise relationship between the audience and the media. She is fascinated by who within the audience has been critical of the political stance taken by the media when reporting events, as well as the selection and reliability of the news reports.

Chen Xi is conversant with the varying political symbols and forms of propaganda that are linked to different eras. Just as big-character posters (*da zi bao*), banners and flags have been used to represent the Cultural Revolution, in her paintings CCTV represents absolute authority and the government, and TV sets are the one-way messengers of propaganda.

[1] 陳曦個人專訪 2016/2/15，北京。
S. NG, personal communication, February 15, 2016

到廿一世紀(2004-2007)的《皇后的新裝》系列(圖三)是她透過女性的胴體表達不理世俗眼光、內心追求自由解放的渴望的油畫作品。畫中主角身體上的泡沫，一方面顯示了個人與社會的隔幕，即不夠透徹，另一方面增加了畫面如夢幻泡影的不真實性，這都是她希望讓觀眾自己解讀的。在風格上，很容易令人聯想到德國藝術家傑哈·李希特(Gerhard Richter)模擬對焦不清的照片的經典風格油畫。

若言李希特的作品表現出相互矛盾的真實性，陳曦的作品便是遊走於真實與虛構之間。她一直強調其作品中沒有表達個人情感，只是冷眼旁觀。她筆下的人物和社會都是描繪日常生活瑣碎事。陳的老師易英將她這一時期風格的作品歸為「後新生代」[2]，而而藝評家楊小彥則以「新生代」[3]形容她此時描繪平淡生活細節的作品，旨在試圖徹底瓦解或顛覆自新中國成立以來在油畫中所形成的宏大敘事手法。

經過約十年(1997-2007)的調整期，陳曦不再受學院外風起雲湧的藝壇影響，自己做自己的創作，獨立生存，風格亦慢慢由粗野變成柔和。

Beginning in 2006, Chen Xi was invited to paint pictures of televisions by a friend who runs MTV. The *Be Memorized* oil paintings were initiated with this invitation, and the series has grown from eighteen paintings in 2009 to the current series of twenty-two. This group of paintings is one of the milestones in her artistic career. Beginning with the fauvism of her early paintings, to her expressive style in the 1990s (Fig. 2), she eventually gave up the use of intense colour as a vehicle for describing light, and the use of brightly coloured contrasts and wild brushstrokes as a means for expressing emotion. *Be Memorized* is an ambitious attempt to abandon her previous styles and to move towards a realistic form of painting, a hyperrealism. Despite this major stylistic shift, the core of the work remains the same—the recent works are also the result of her past experience and evolving skill as a painter.

In the 1980s, Chen Xi worked in various styles, but painted primarily in rough brushstrokes and sharp colours, focusing on the representation of memories from her time studying at the high school attached to the Sichuan Fine Arts Institute. In the 1990s, her works became an expansion of the surrounding world. Instead of documenting her school life, she shifted her attention to the lives of ordinary people within the local community. Most of these paintings were realistic portrayals of people who went largely ignored in her neighborhood.

[2]  易英，〈後新生代與陳曦的繪畫〉，陳曦：《自由出逃——陳曦的藝術世界》（廣州，2011），頁55。
    Yi Ying, 'The New Generation and Chen Xi's Paintings', *Escaping Freely: Chen Xi's Art World* (Guangzhou, 2011), p. 55.
[3]  楊小彥，〈自由出逃，還是出逃的自由〉，陳曦：《自由出逃——陳曦的藝術世界》（廣州，2011），頁187。
    Yang Xiaoyan, 'Trivial in Cold Sight and Self-indulgence in Expression—On the Mundane Feelings of the Oil Painter Chen Xi', *Escaping Freely: Chen Xi's Art World* (Guangzhou, 2011), p. 187.

到了《被記憶》(2006-2010) 時期，她對中國人民和社會發展的興趣比對她自己或以圍繞個人為中心的命題更大。這與她的理性思維方式和個性有強烈的因果關係。她怕沉悶、反叛、不喜歡家長式的訓示，要突破現狀等的個性不無有關。她質疑某部份人對媒體的報導從沒有批判的思考。

徘徊在大眾與小眾之間，電視很大眾，藝術則很小眾。如傳統中國畫般，有留白才能讓觀眾有思考空間，不會為解釋而解釋。她並不是要創作藝術去討好觀眾，而是要用藝術與觀眾溝通，想知道他們如何回應，超越電視的單向溝通。

Another series worth noting is the *Queen's New Clothes*, created between 2004 and 2007 (Fig. 3), through which she illustrates her thoughts on women's liberation, and expresses an internal desire to pursue freedom and liberation. The bubbles that appear on the naked body represent the layers placed between individuals and society, their loose and vague relationship. Some of the bubbles also appear over the body, creating a surreal visual effect similar to a dreamlike state, which allows each person to interpret a distinct meaning. This painting style is reminiscent of the German artist Gerhard Richter (b. 1932) and his classic photo paintings, which are large-scale oils that imitate partly blurred photographs, or were based on images from family albums and newspapers.

If Richter reveals the conflict between the 'real' and the 'imaginary', then Chen Xi's works illustrate the state between 'reality' and the 'virtual world'. She stresses that her works do not show her personal feelings; she describes herself strictly as an observer. The people and society that she draws are taken from swatches of daily life. Her painting teacher at the Central Academy of Fine Arts (CAFA) has classified Chen Xi as 'post new generation'[2], while Yang Xiaoyan has grouped her into the 'new

generation'[3]. The 'New generation' refers to young artists who no longer follow the style of their mentors, and now paint primarily grand scenes and historic events and figures. Unlike painters since the founding of the People's Republic of China (PRC), this group of artists focuses on the details of ordinary life; their primary intent is to upset the norms of realism.

After an adjustment period of around ten years (1997–2007), Chen Xi stepped away from the influence of the fluctuating art world. Along with this independence from the academy, her artistic style has gradually altered from being wild and rough to fine and soft.

During the *Be Memorized* period (2006–2010), she became more interested in detailing the lives of Chinese people and societal development, rather than focusing on herself as an artist, or her own responses to the historic events and seminal TV shows. Like many artists, she has always been afraid of becoming boring and has an innate rebellious streak that opposes paternalistic instruction. Chen Xi believes that the status quo and the news presented through the medium of TV require critical thinking and a constant skepticism.

As in traditional Chinese art, Chen Xi's works leave a certain amount of empty space for each person to fill in. It is unnecessary for her to explain her views about the individual events. This aspect of her work is what I treasure most about the series and her entire oeuvre. Instead of creating works that appeal to the status quo, she uses art to communicate in the hopes of eliciting a response from a segment of the population that might not normally pay attention to art.

# So We Remember

PAINTINGS FROM THE
*BE MEMORIZED*
SERIES

所以記憶

《被記憶》系列

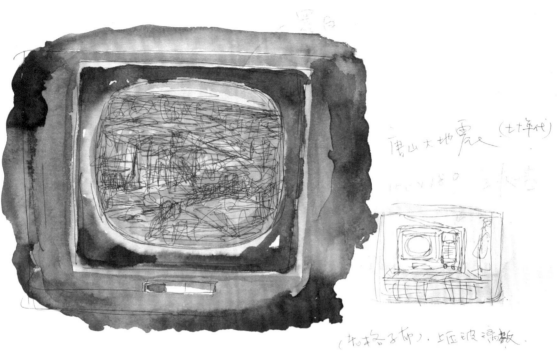

唐山大地震（七十年代）

（松格子布）. 垫玻璃板.

此时正是四川汶川大地震之后
实施完成合. 2008.

唐山大地震
TANGSHAN EARTHQUAKE

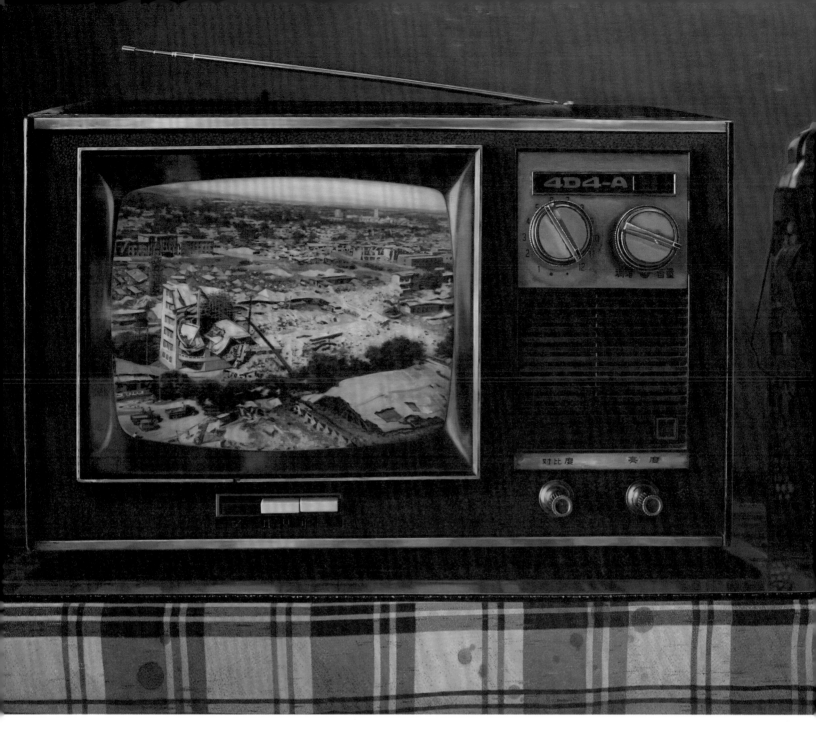

2008

布面油畫
Oil on canvas
150×180cm (無框 / without frame)
156×186cm

2008

紙上水彩
Watercolour on paper
31×41cm (無框 / without frame)
71×51cm

所以人記憶

So We Remember

毛 主 席 逝 世

CHAIRMAN MAO'S MEMORIAL CEREMONY

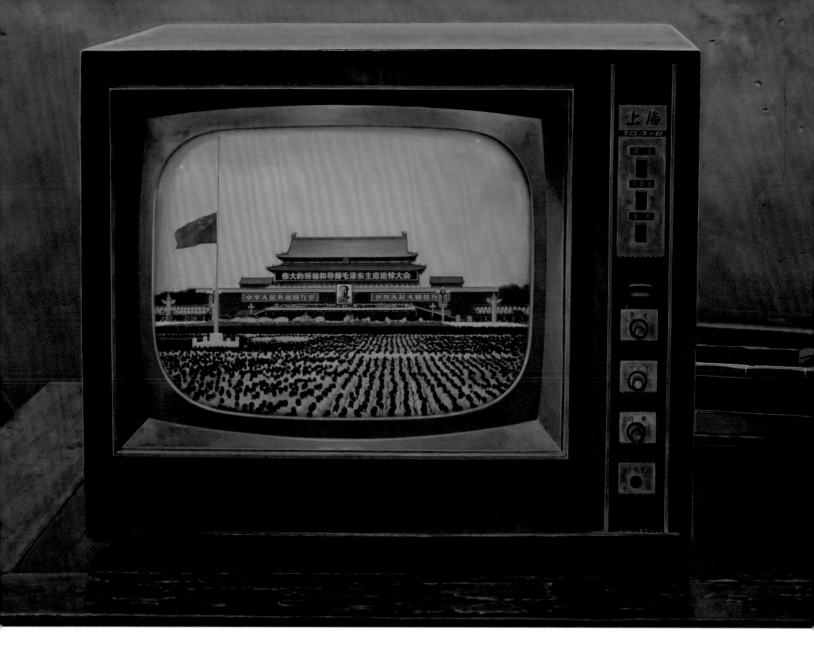

2008

布面油畫
Oil on canvas
155×210cm (無框 / without frame)
161×216cm

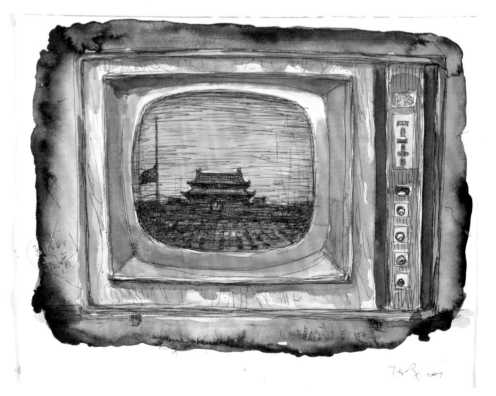

2007

紙上水彩
Watercolour on paper
31×41cm (無框 / without frame)
71×51cm

所以記憶

SoWeRemember

〈 新 聞 聯 播 〉 首 播

INAUGURAL BROADCAST
OF CCTV NEWS

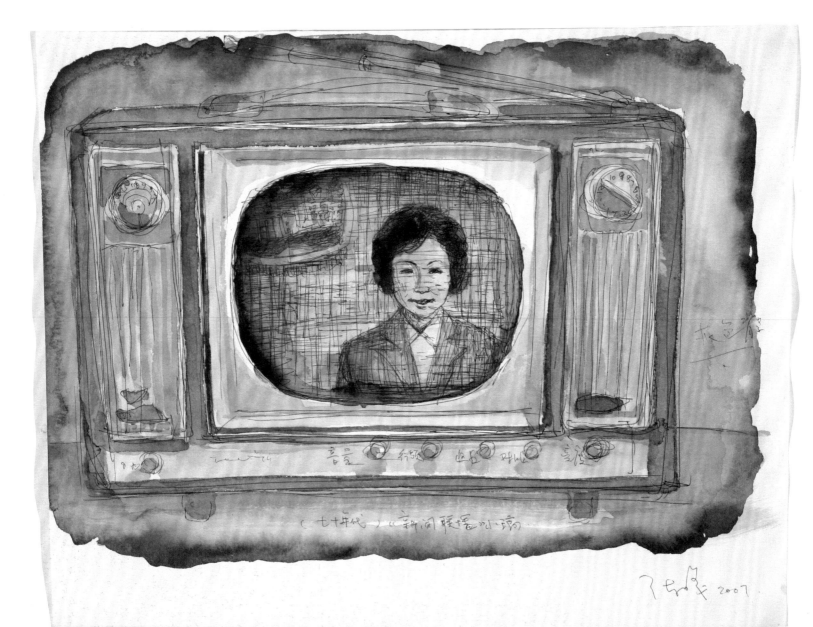

2007

紙上水彩
Watercolour on paper
31×41cm (無框 / without frame)
71×51cm

2008

布面油畫
Oil on canvas
130×180cm (無框 / without frame)
136×186cm

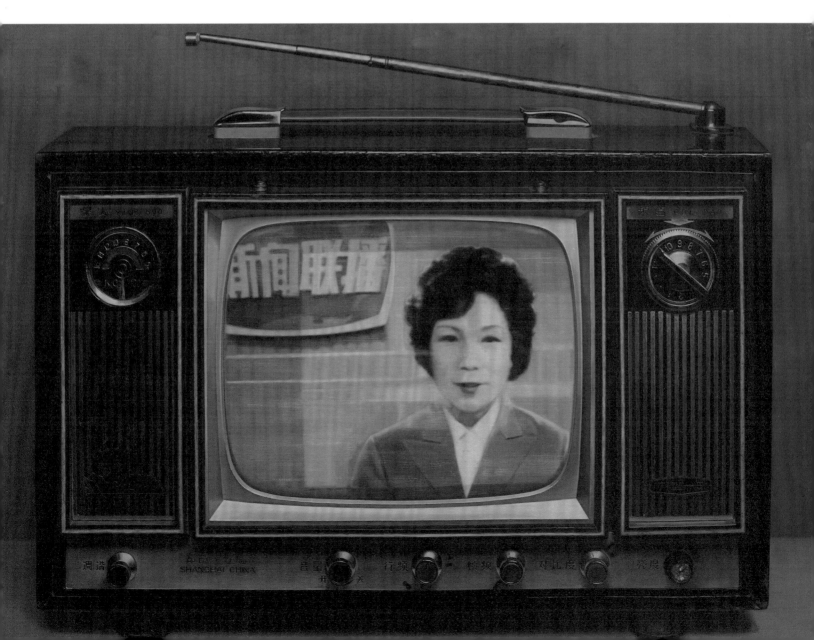

審判「四人幫」
GANG OF FOUR TRIAL

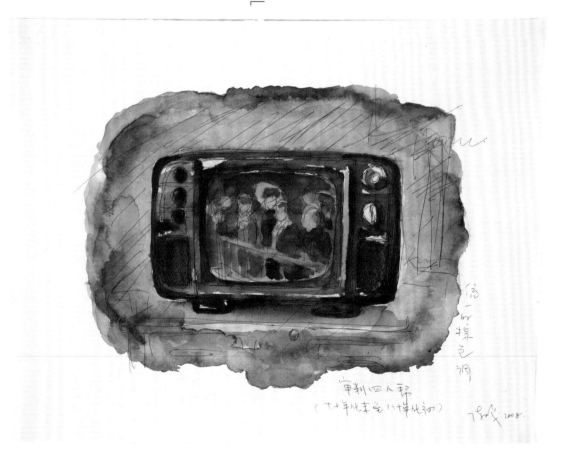

2008　2008

紙上水彩　布面油畫
Watercolour on paper　Oil on canvas
31×41cm (無框 / without frame)　130×180cm (無框 / without frame)
71×51cm　136×186cm

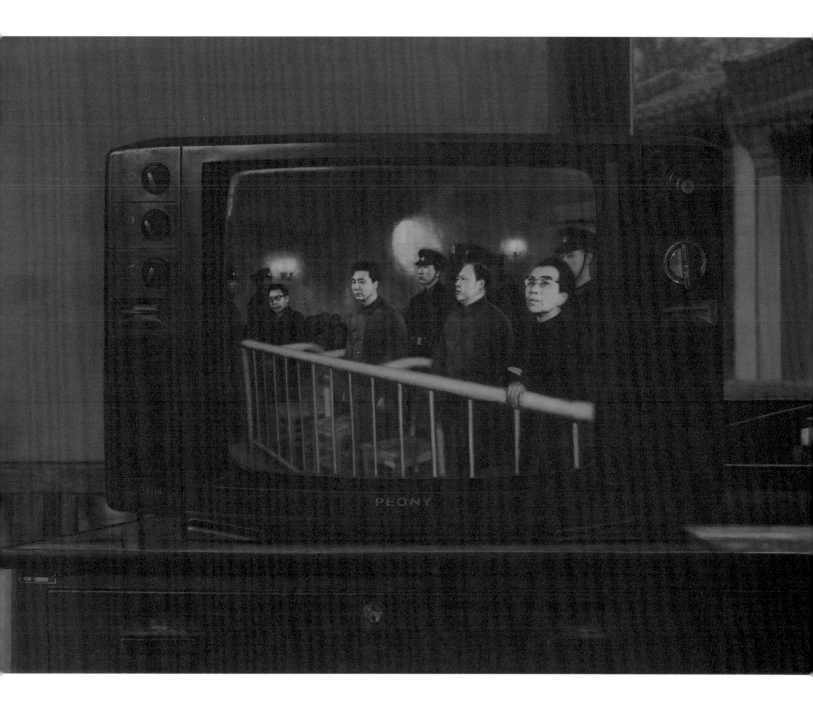

只　生　一　個　好
ONE-CHILD POLICY

2009
紙上水彩
Watercolour on paper
31×41cm (無框 / without frame)
71×51cm

2010
布面油畫
Oil on canvas
150×180cm (無框 / without frame)
156×186cm

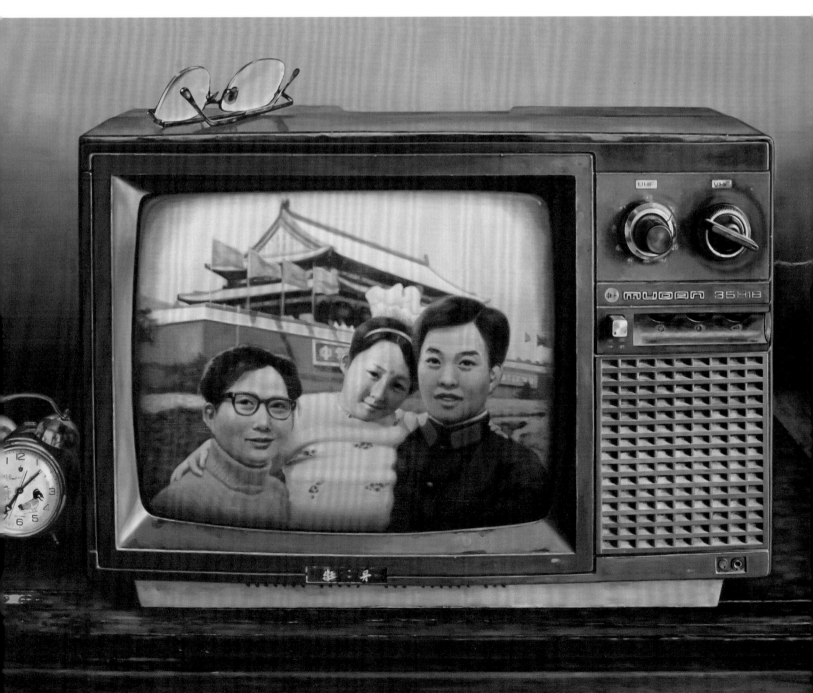

所以記憶<br>
So We Remember

大閱兵<br>
MILITARY PARADE

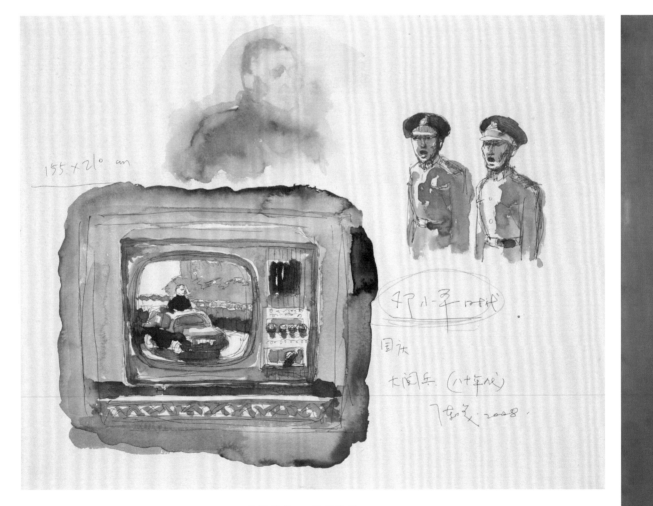

2008   2008

紙上水彩   布面油畫<br>
Watercolour on paper   Oil on canvas<br>
31×41cm (無框 / without frame)   155×210cm (無框 / without frame)<br>
71×51cm   161×216cm

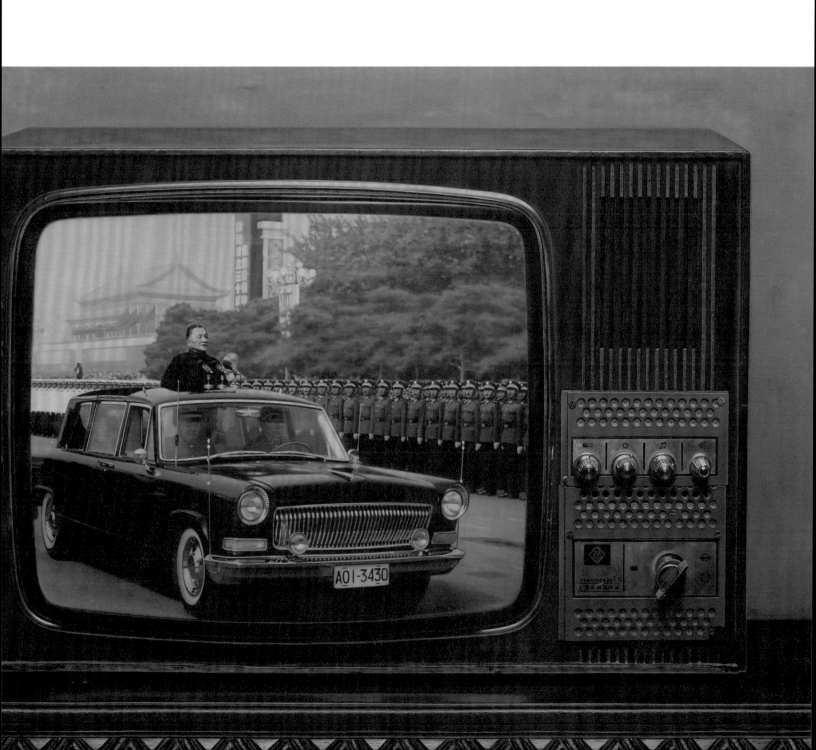

所以記憶

So We Remember

女排在世界舞臺

WOMEN'S VOLLEYBALL TEAM ON THE WORLD STAGE

女排三奪冠
（八十年代）

2007        2007

紙上水彩        布面油畫

Watercolour on paper    Oil on canvas

31×41cm (無框 / without frame)    150×180cm (無框 / without frame)

71×51cm        156×186cm

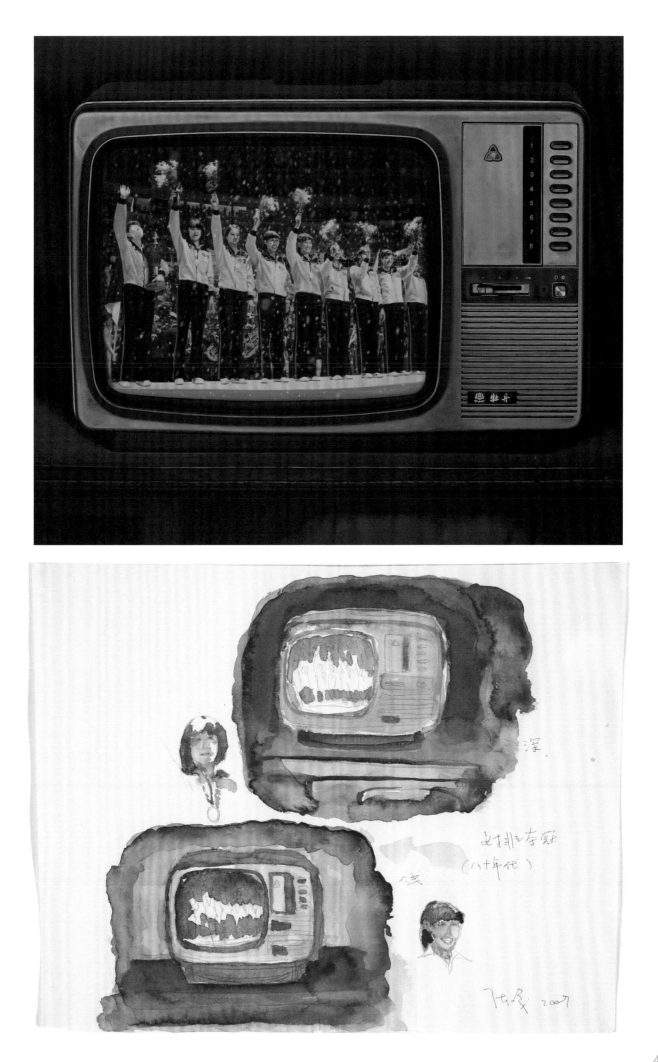

所以記憶
So We Remember

春 節 聯 歡 晚 會
SPRING FESTIVAL
GALA EVENING

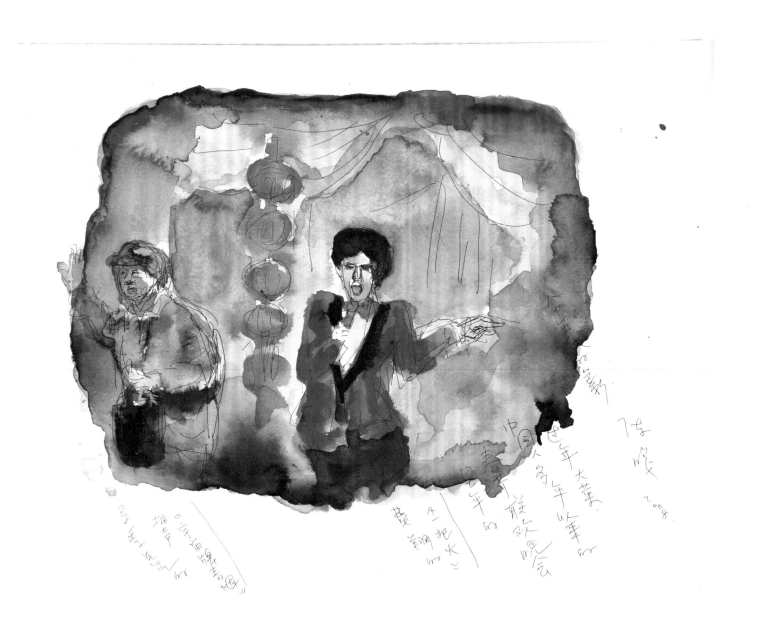

2008

紙上水彩
Watercolour on paper
31×41cm (無框 / without frame)
71×51cm

2008

布面油畫
Oil on canvas
150×180cm (無框 / without frame)
156×186cm

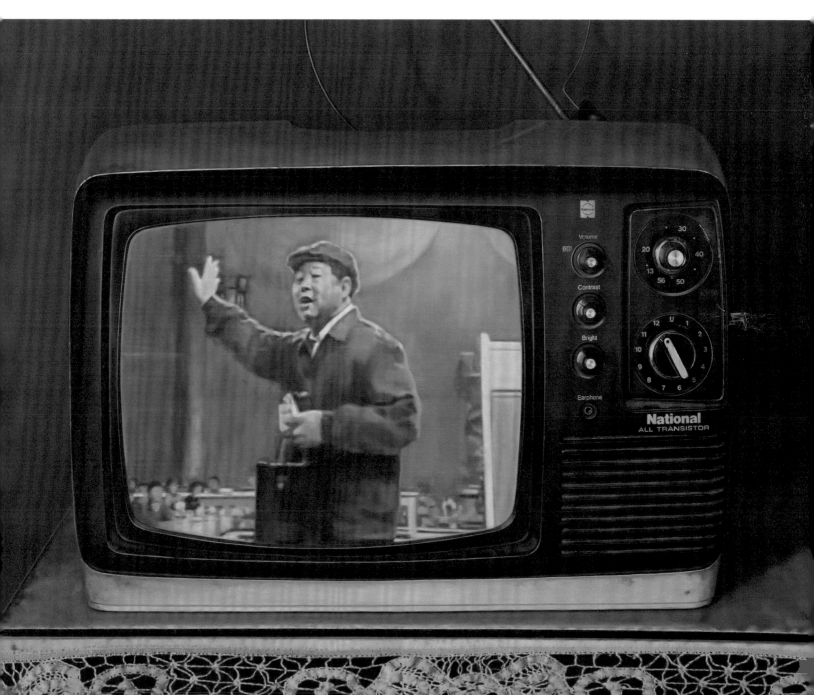

所以記憶
SoWeRemember

特區建設
CREATION OF SPECIAL ECONOMIC ZONES

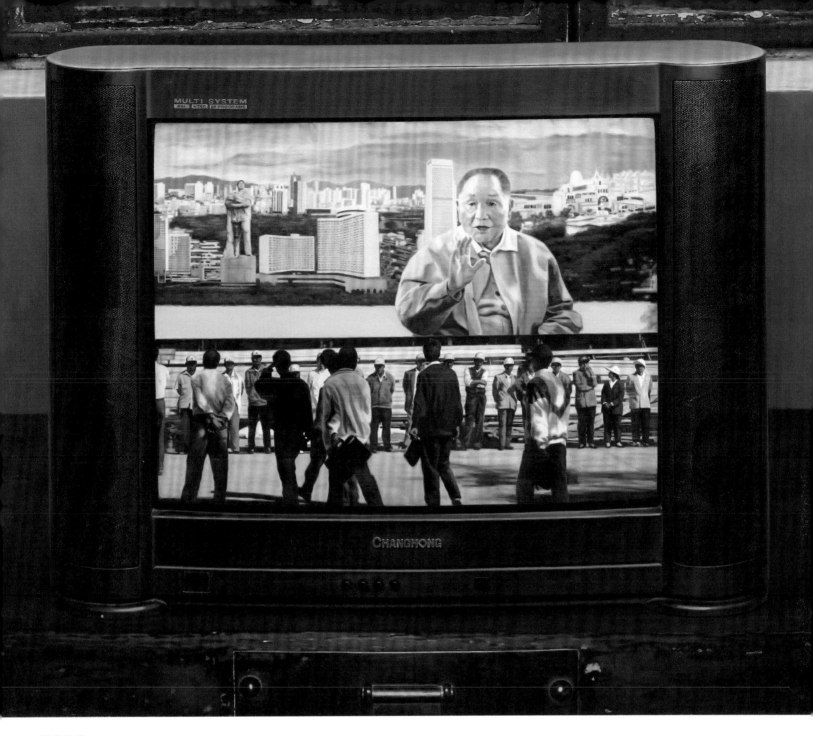

2009

布面油畫
Oil on canvas
150×180cm (無框 / without frame)
156×186cm

2008

紙上水彩
Watercolour on paper
31×41cm (無框 / without frame)
71×51cm

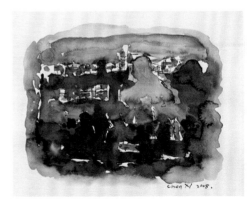

所以記憶
So We Remember

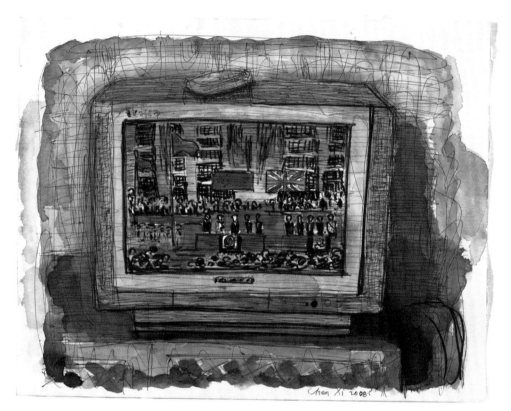

香港回歸
HONG KONG'S RETURN

2008　2008

紙上水彩　布面油畫
Watercolour on paper　Oil on canvas
31×41cm (無框 / without frame)　155×210cm (無框 / without frame)
71×51cm　161×216cm

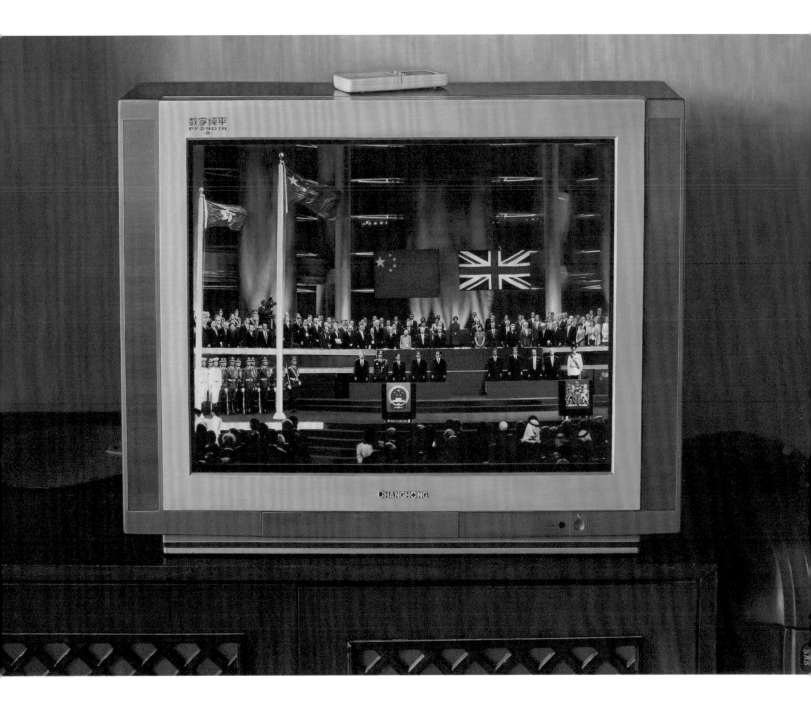

股市

STOCK MARKET

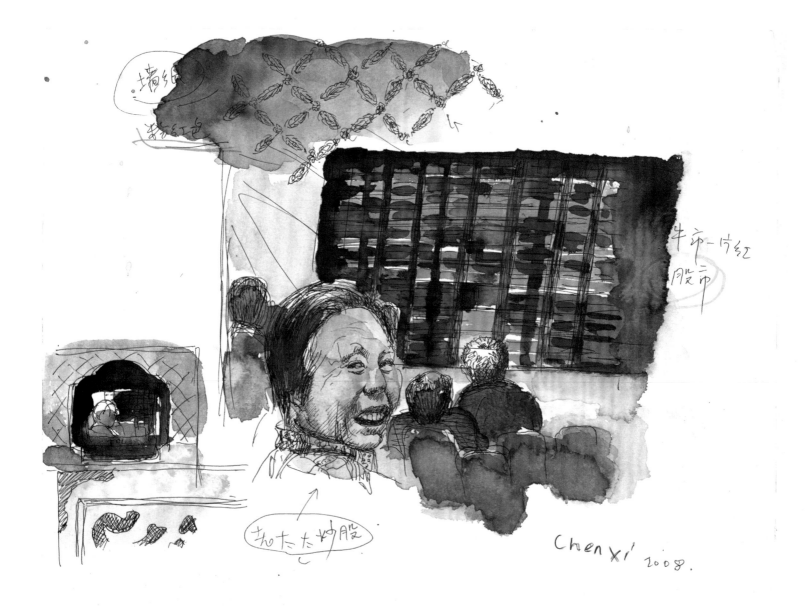

Chen Xi 2008.

2008

紙上水彩
Watercolour on paper
31×41cm (無框 / without frame)
71×51cm

2009

布面油畫
Oil on canvas
150×180cm (無框 / without frame)
156×186cm

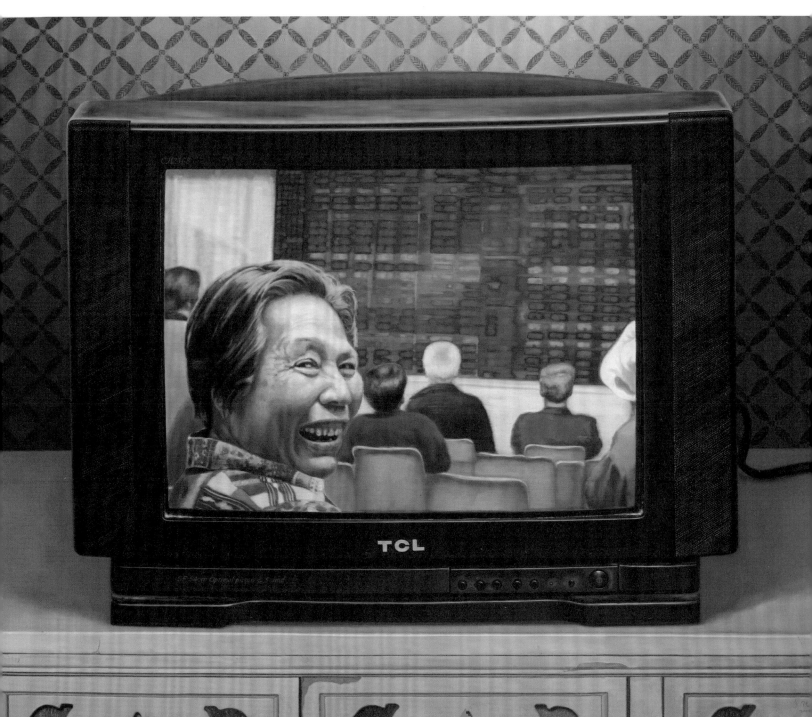

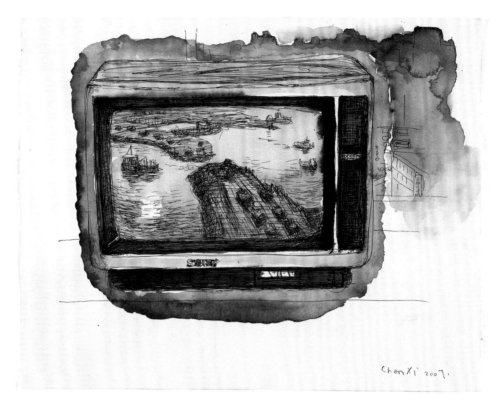

三峽工程

THREE GORGES PROJECT

2007　2009

紙上水彩　布面油畫

Watercolour on paper　Oil on canvas

31×41cm (無框 / without frame)　150×180cm (無框 / without frame)

71×51cm　156×186cm

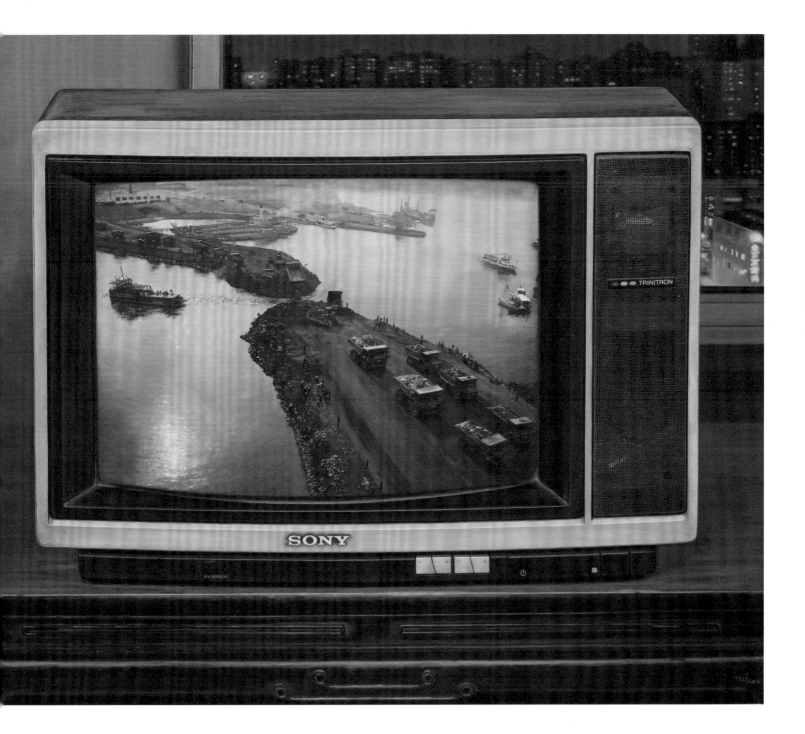

SoWeRemember

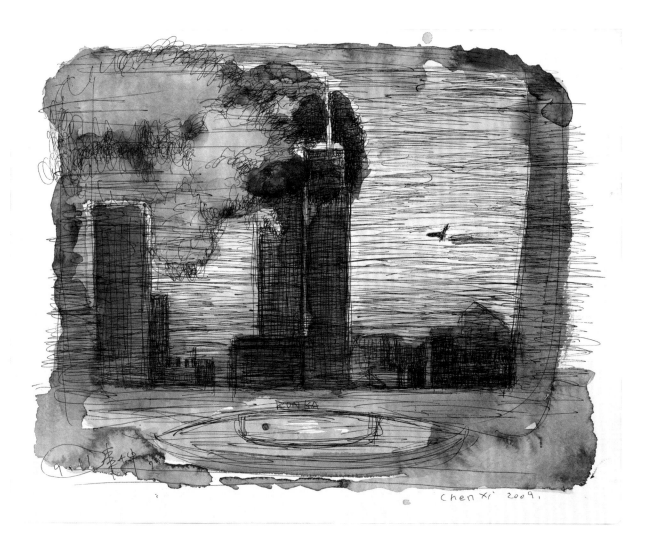

Chen Xi 2009.

「9／11」事件

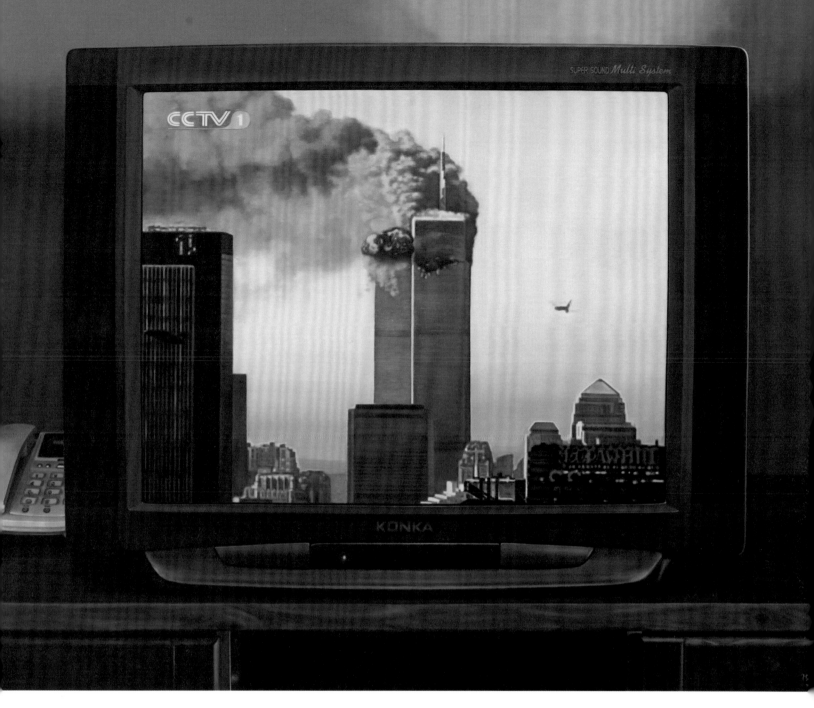

2009

布面油畫
Oil on canvas
150×180cm (無框 / without frame)
156×186cm

2009

紙上水彩
Watercolour on paper
31×41cm (無框 / without frame)
71×51cm

所以記憶
SoWeRemember

「非典」時期
IN THE TIME OF SARS

2009　2010

紙上水彩　布面油畫
Watercolour on paper　Oil on canvas
31×41cm (無框 / without frame)　130×180cm (無框 / without frame)
71×51cm　136×186cm

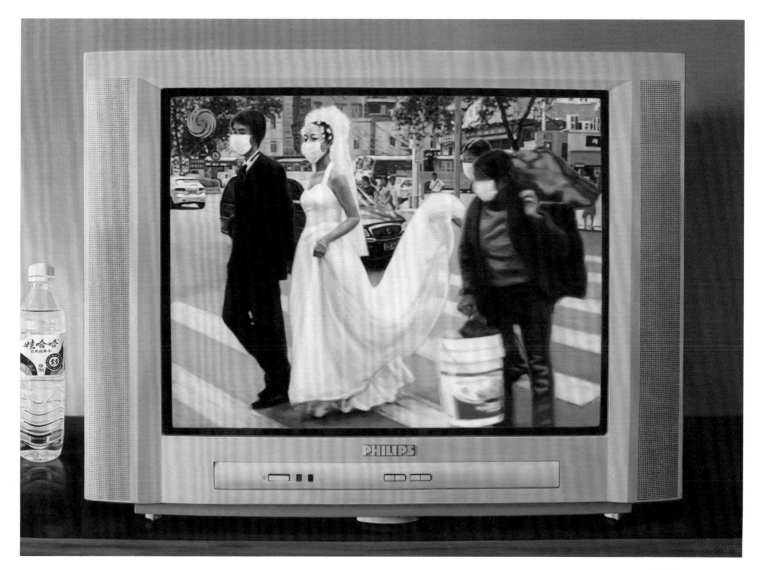

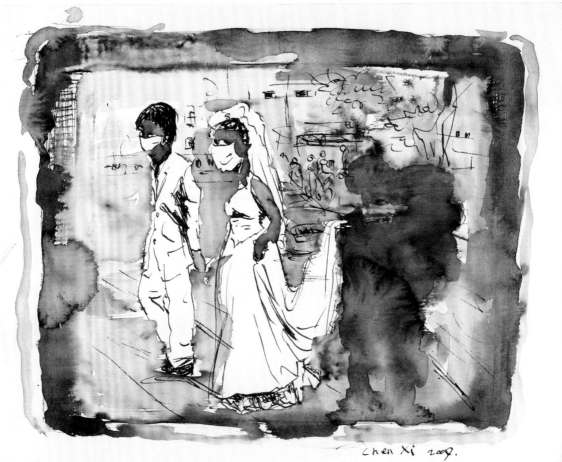

SoWeRemember

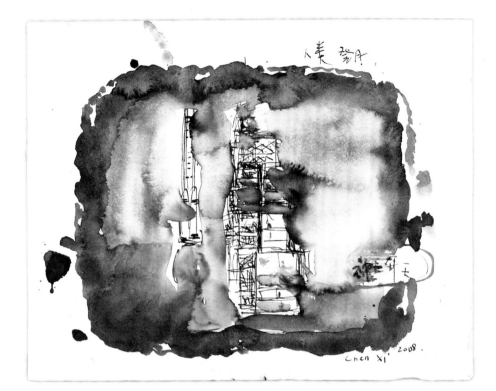

神舟五號升空

SHENZHOU SPACECRAFT LAUNCH

| 2008 | 2009 |
|---|---|
| 紙上水彩 | 布面油畫 |
| Watercolour on paper | Oil on canvas |
| 31×41cm (無框 / without frame) | 150×180cm (無框 / without frame) |
| 71×51cm | 156×186cm |

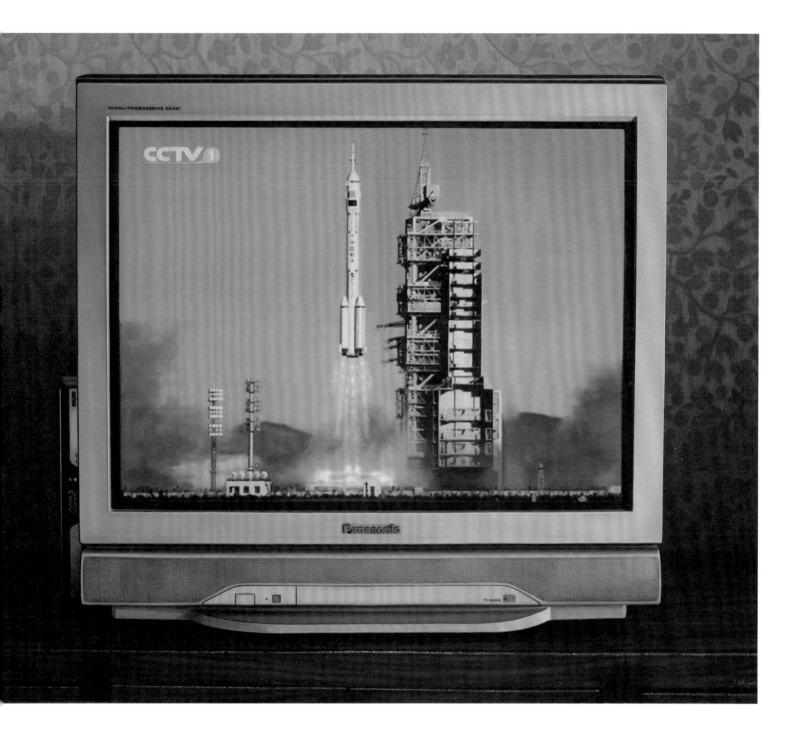

超 級 女 聲
SUPER VOICE GIRLS

2007　2007

紙上水彩　布面油畫
Watercolour on paper　Oil on canvas
31×41cm (無框 / without frame)　130×180cm (無框 / without frame)
71×51cm　136×186cm

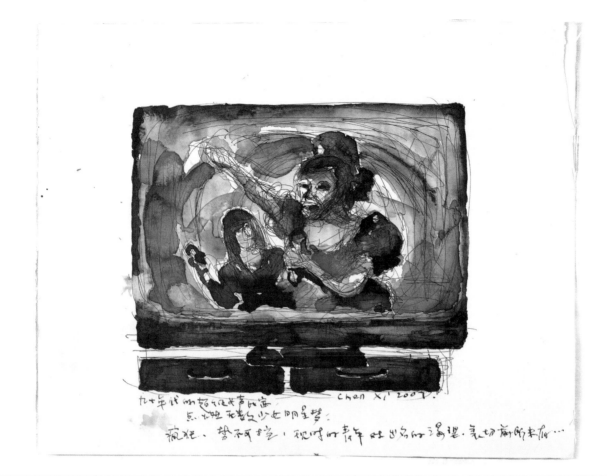

九十年代的超级巨星演唱会
点火地 无数少女明星梦
疯狂、梦不可望，犯时的青年 此别名的渴望 气切脱脱未来…

Chen Xi 2007.

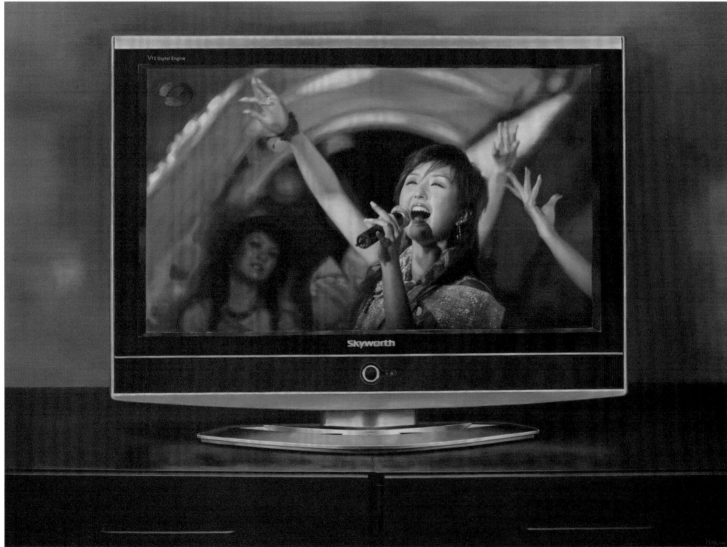

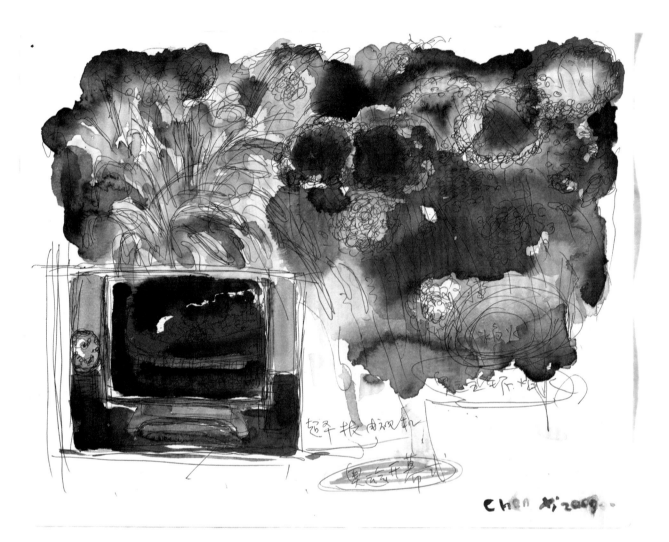

奧 運 會 開 幕

OPENING CEREMONY
OF THE OLYMPIC GAMES

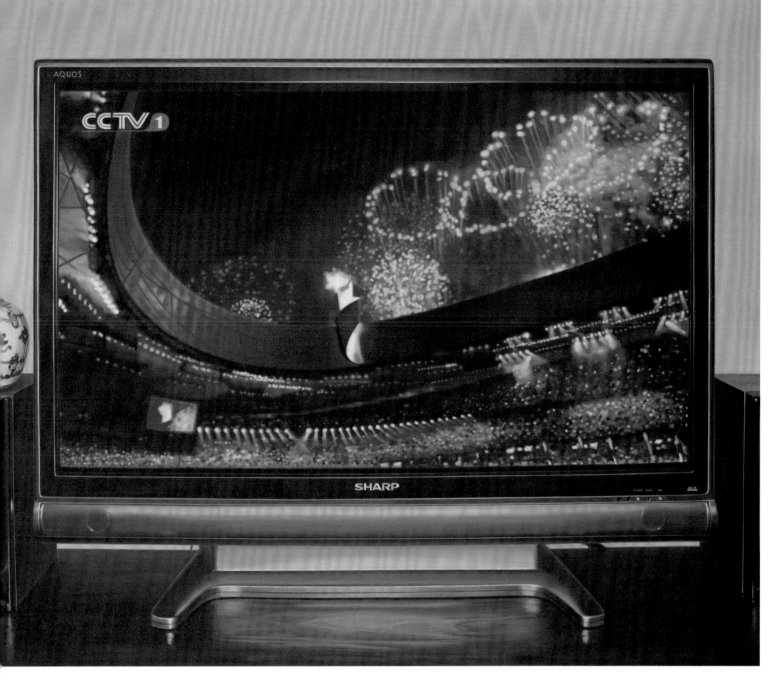

2010

布面油畫
Oil on canvas
150×180cm (無框 / without frame)
156×186cm

2009

紙上水彩
Watercolour on paper
31×41cm (無框 / without frame)
71×51cm

所以記憶

SoWeRemember

國慶 60 週年

60TH ANNIVERSARY OF NATIONAL DAY

2009

紙上水彩
Watercolour on paper
31×41cm (無框 / without frame)
71×51cm

2010

布面油畫
Oil on canvas
155×210cm (無框 / without frame)
161×216cm

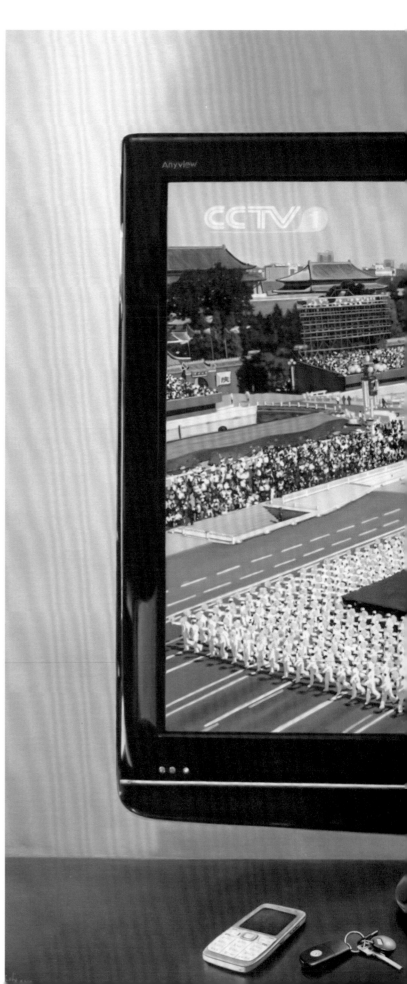

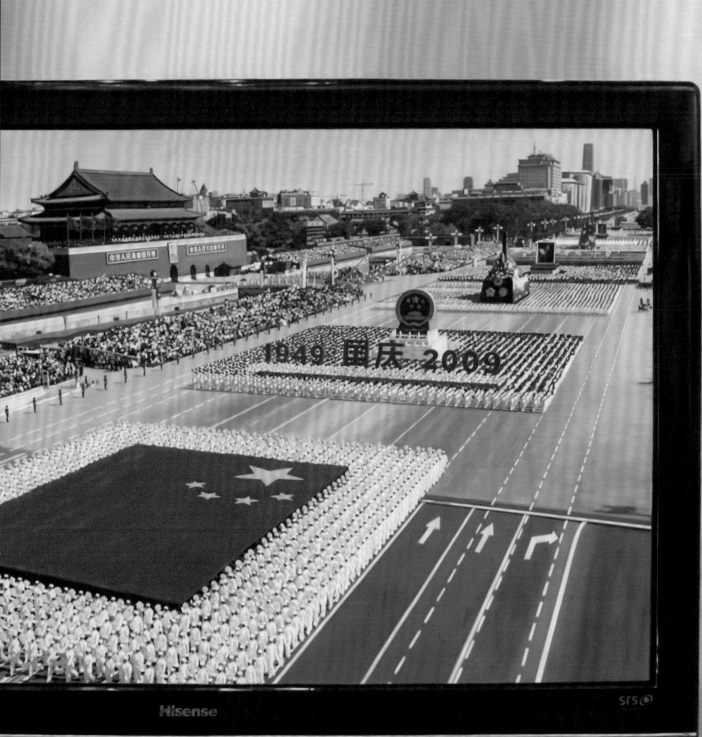

# SoWeRemember

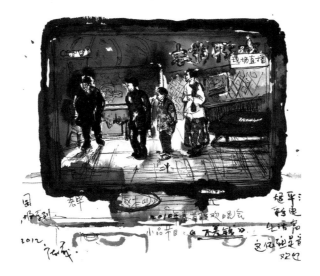

不差錢

NOT SHORT OF MONEY

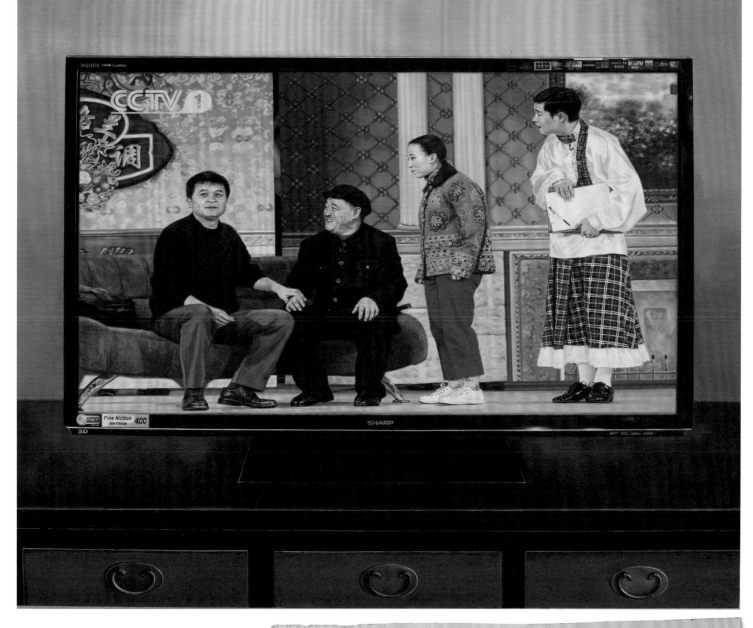

2013

布面油畫
Oil on canvas
150×180cm (無框 / without frame)
156×186cm

2012

紙上水彩
Watercolour on paper
31×41cm (無框 / without frame)
71×51cm

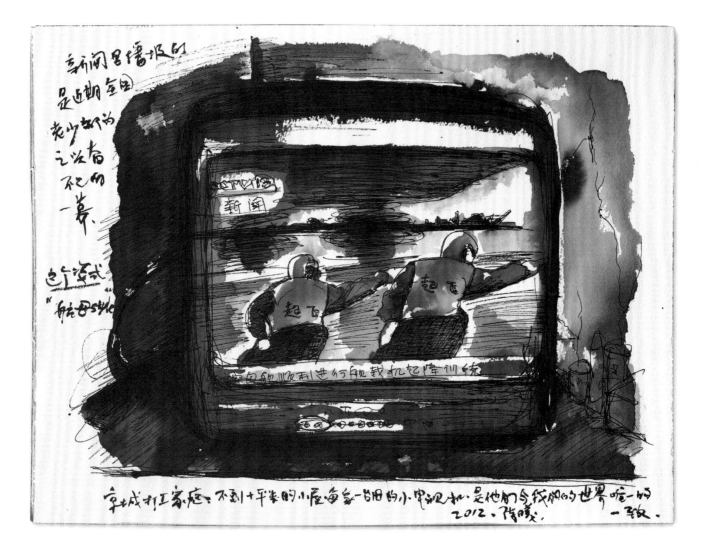

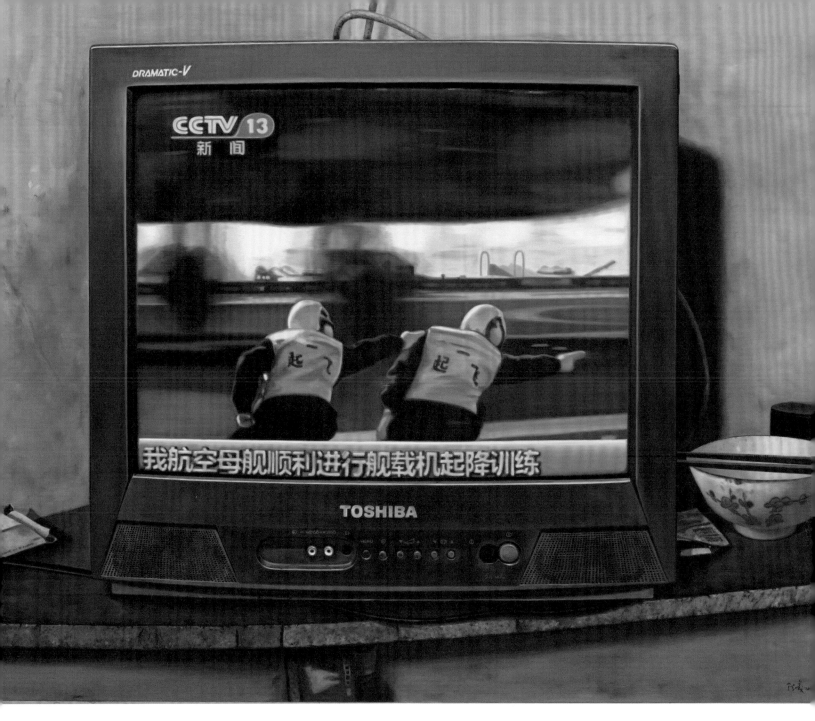

2012

布面油畫
Oil on canvas
150×180cm（無框 / without frame）
156×186cm

2012

紙上水彩
Watercolour on paper
31×41cm（無框 / without frame）
71×51cm

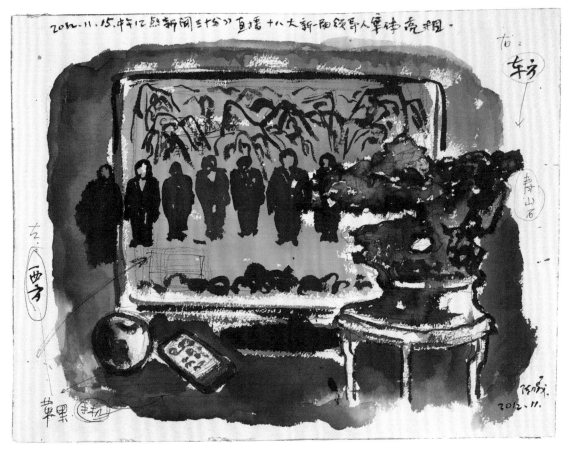

2012

紙上水彩
Watercolour on paper
31×41cm (無框 / without frame)
71×51cm

CHINA'S NEW LEADERS　換屆

2012

布面油畫
Oil on canvas
150×180cm (無框 / without frame)
156×186cm

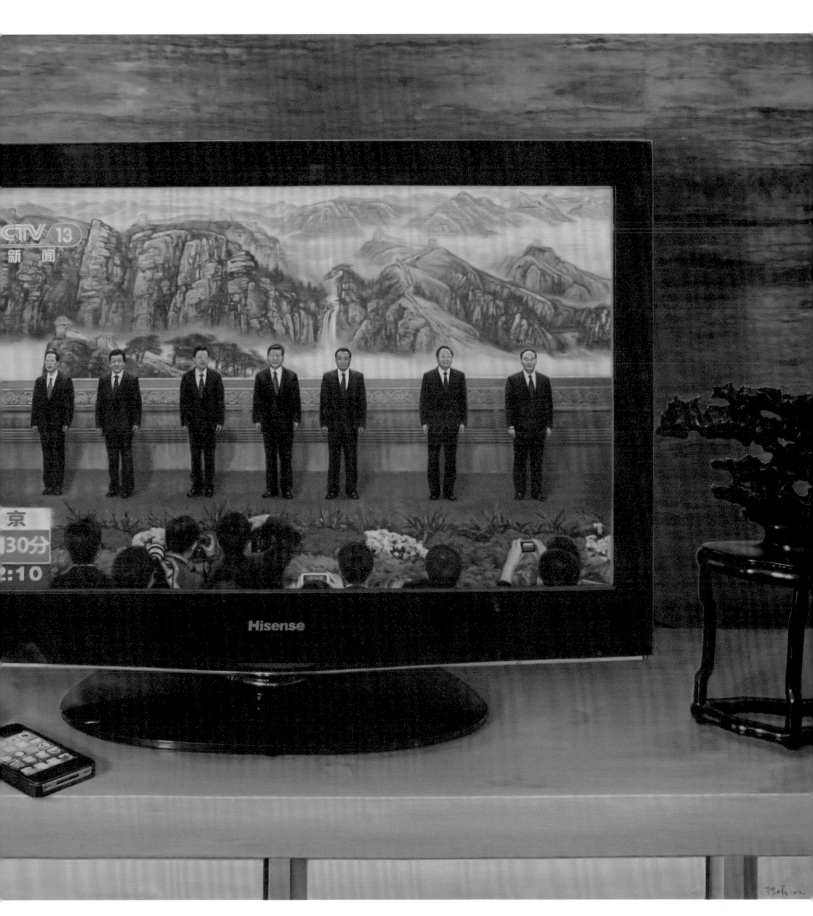

# SoWeRemember

釣魚島
DIAOYU ISLANDS

2012   2012

紙上水彩   布面油畫
Watercolour on paper   Oil on canvas
31×41cm (無框 / without frame)   150×180cm (無框 / without frame)
71×51cm   156×186cm

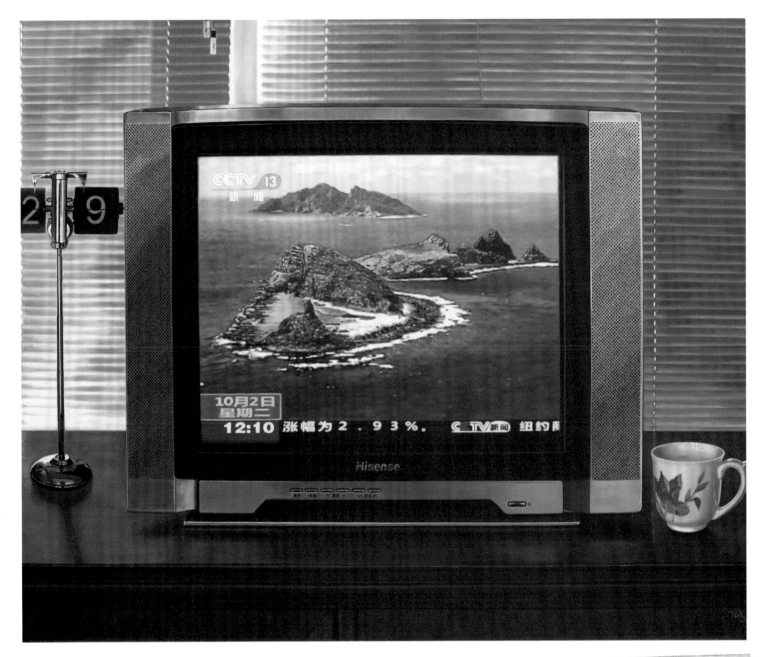

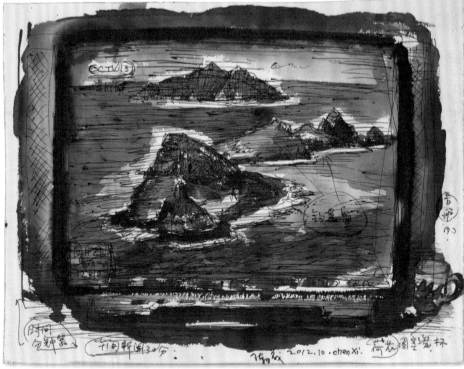